BIG BOOK
OF
ANIMAL
ILLUSTRATIONS

Selected and Arranged by
MAGGIE KATE

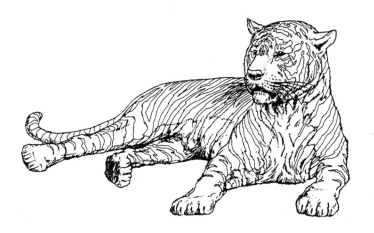

DOVER PUBLICATIONS, INC.
Mineola, New York

Bibliographical Note

Big Book of Animal Illustrations is a new work, first published by Dover Publications, Inc., in 1999. For a complete list of the sources of the illustrations in this book, see p. 124.

DOVER *Pictorial Archive* SERIES

International Standard Book Number: 0-486-40464-1

Manufactured in the United States of America
Dover Publications, Inc., 31 East 2nd Street, Mineola, N.Y. 11501

Publisher's Note

Many talented artists have specialized in observing animals in their natural habitats and depicting them realistically. In the *Big Book of Animal.Illustrations*, a generous sampling of the work of seven outstanding animal illustrators has been brought together. Included in this carefully selected compendium are hundreds of common and rare species from every continent of the world, all climates, and a multitude of habitats. In addition, dozens of dinosaurs and prehistoric mammals are depicted.

This diverse collection of original drawings is an excellent source for anyone seeking authentic views of many kinds of animals. Animals that are closely related, or that live in the same habitat or on one continent, are grouped in appropriate categories and can be surveyed by browsing through a single section of the book. An index provides quick access to the page locations of drawings of specific animals, some of which are presented in more than one category.

Contents

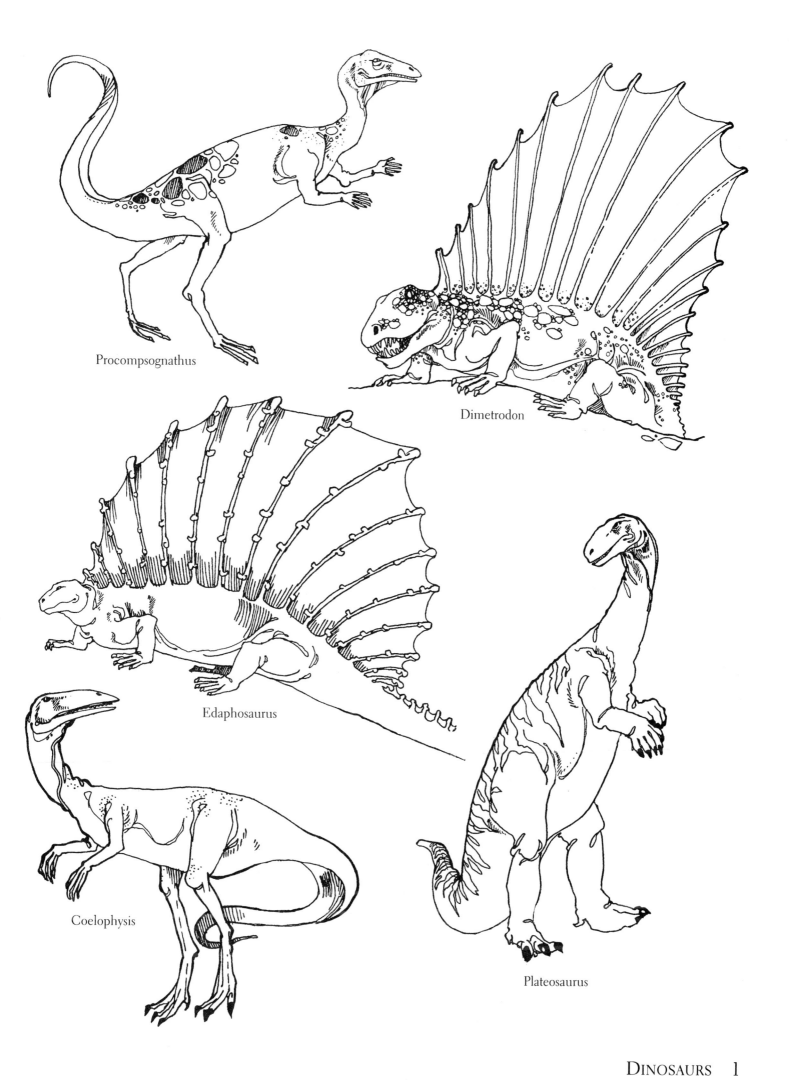

Procompsognathus

Dimetrodon

Edaphosaurus

Coelophysis

Plateosaurus

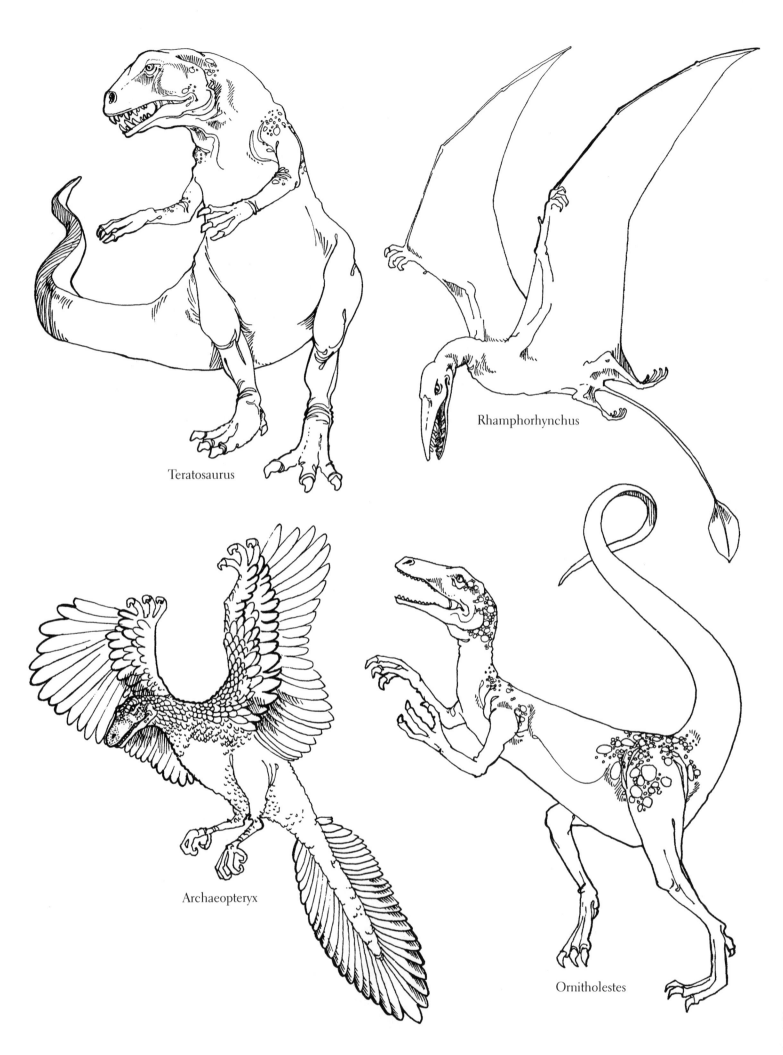

Teratosaurus

Rhamphorhynchus

Archaeopteryx

Ornitholestes

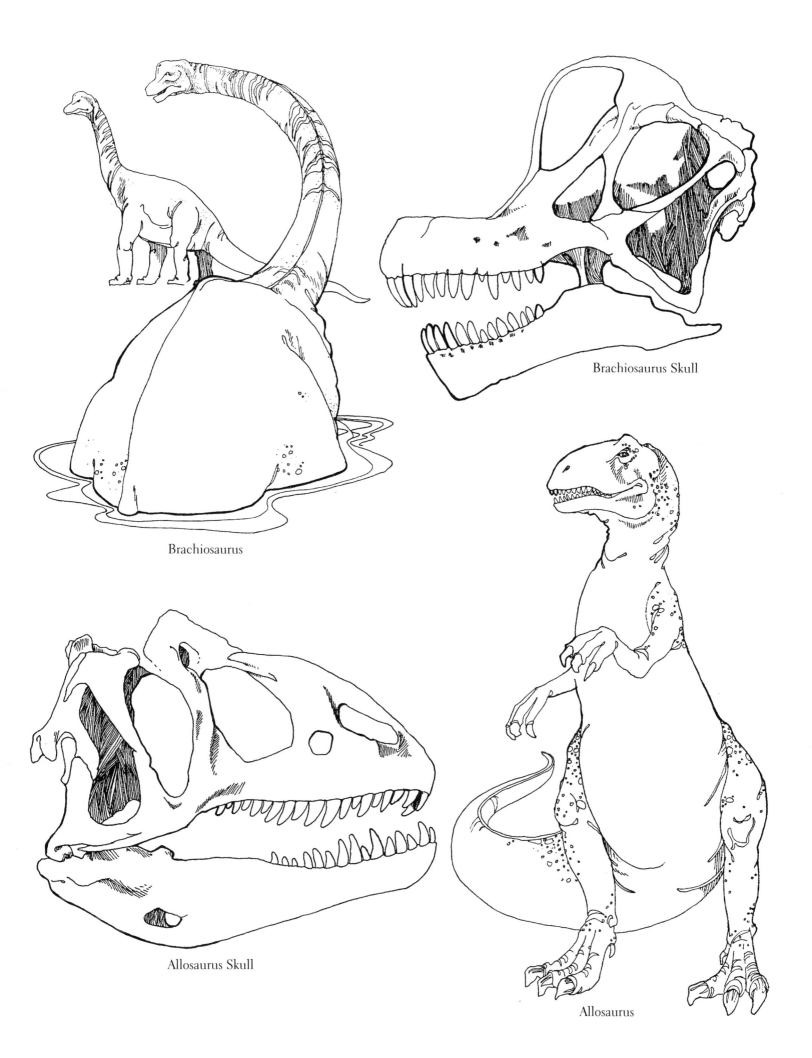

Brachiosaurus Skull

Brachiosaurus

Allosaurus Skull

Allosaurus

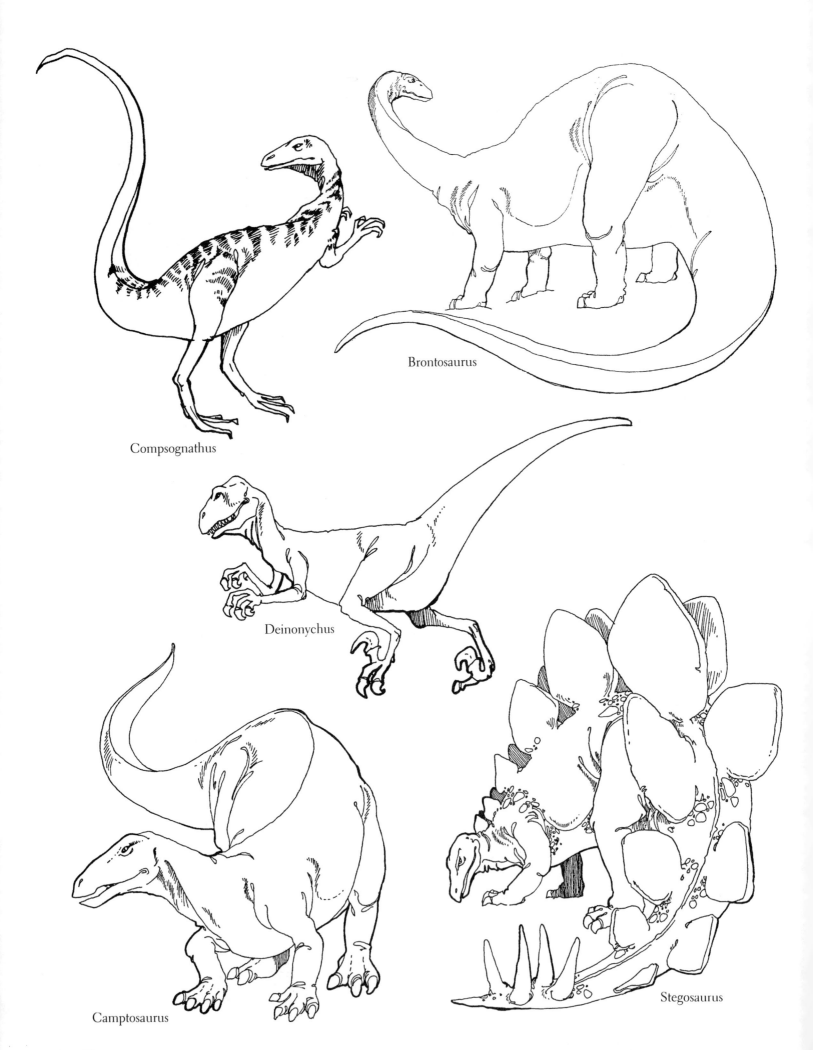

Compsognathus

Brontosaurus

Deinonychus

Camptosaurus

Stegosaurus

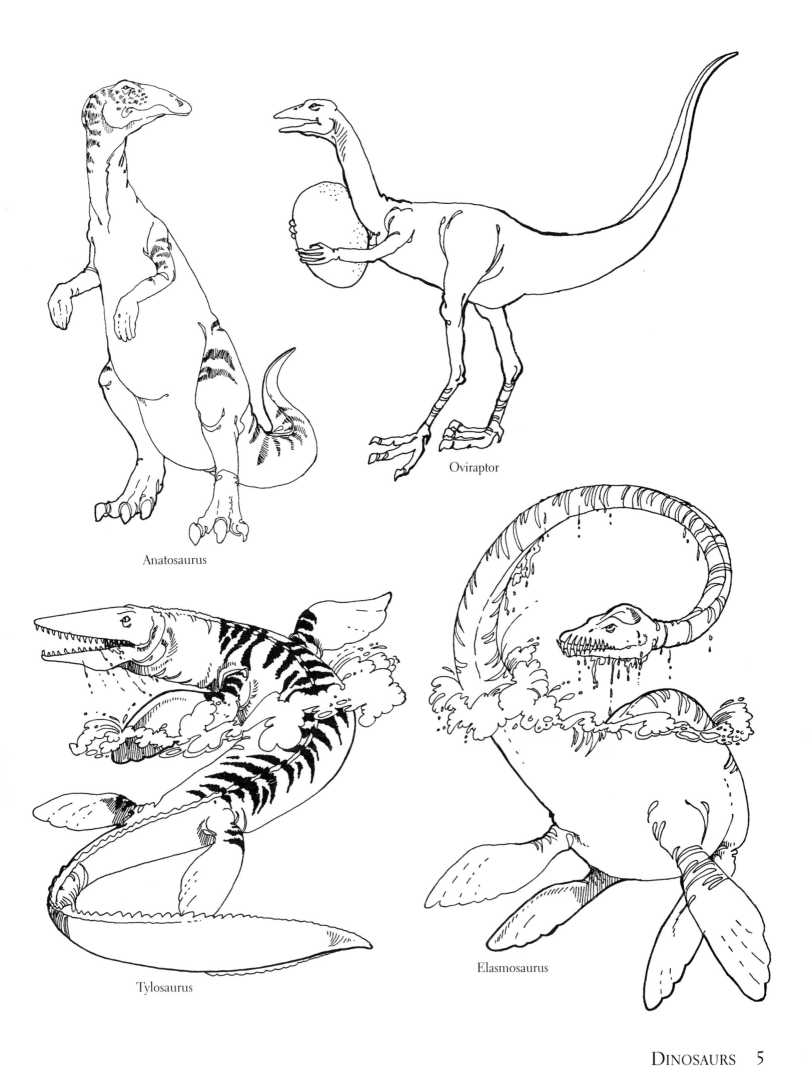

Anatosaurus

Oviraptor

Tylosaurus

Elasmosaurus

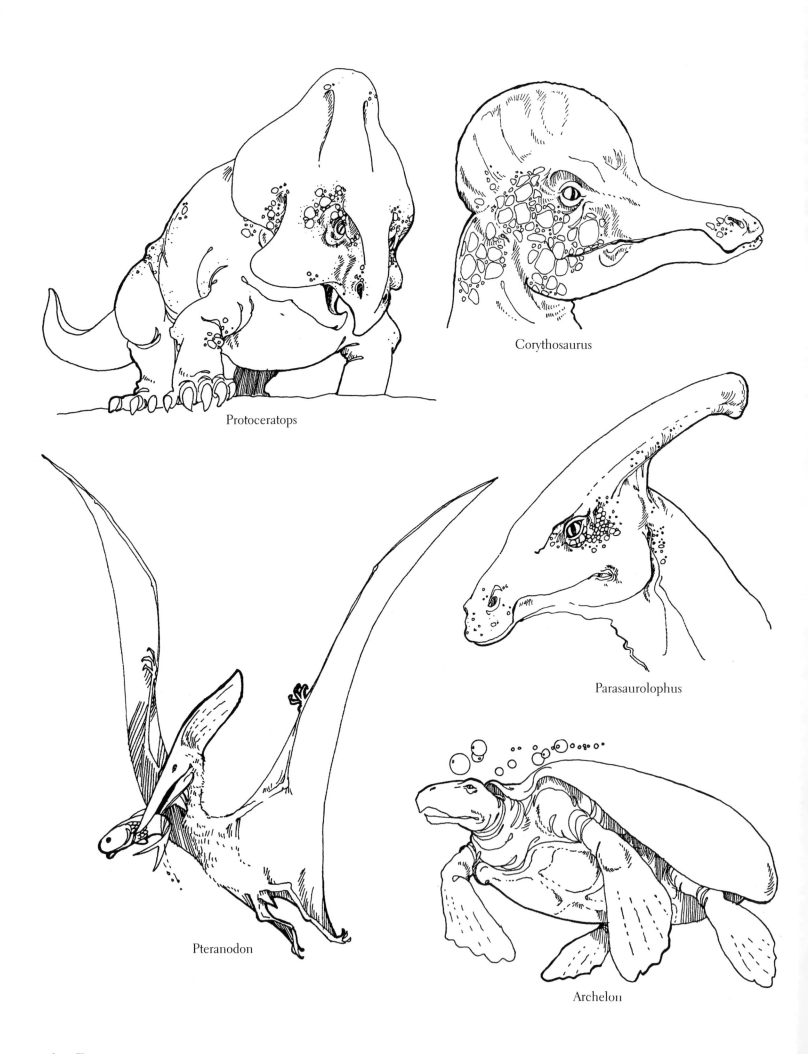

Corythosaurus

Protoceratops

Parasaurolophus

Pteranodon

Archelon

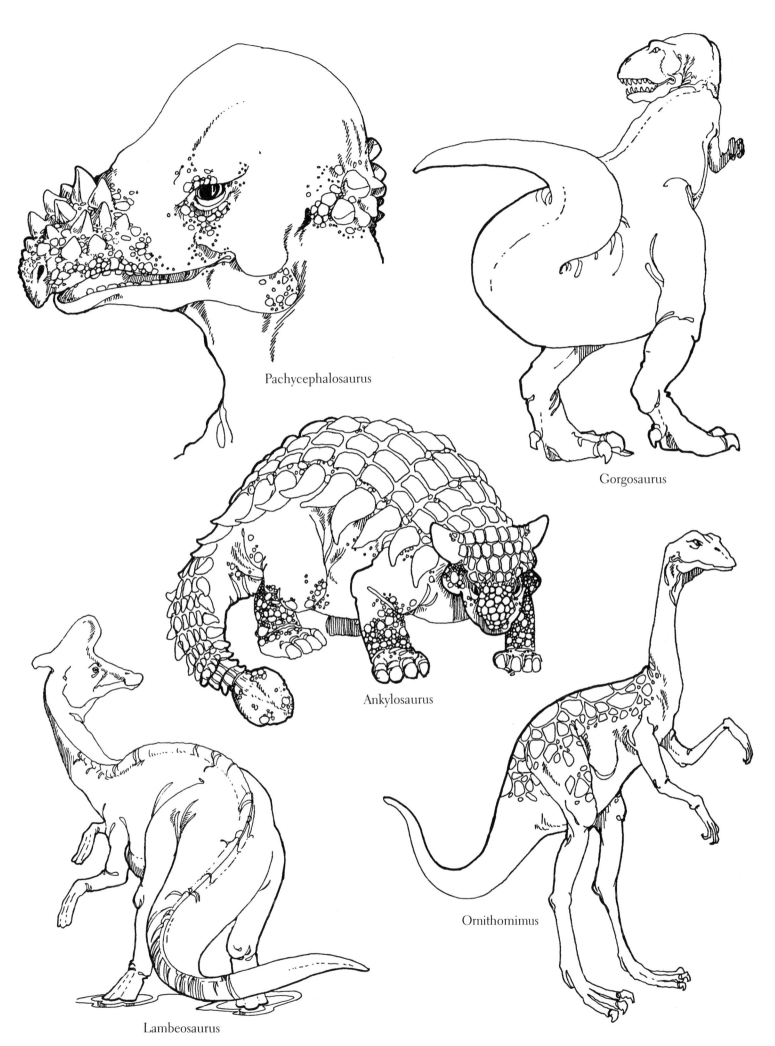

Pachycephalosaurus

Gorgosaurus

Ankylosaurus

Lambeosaurus

Ornithomimus

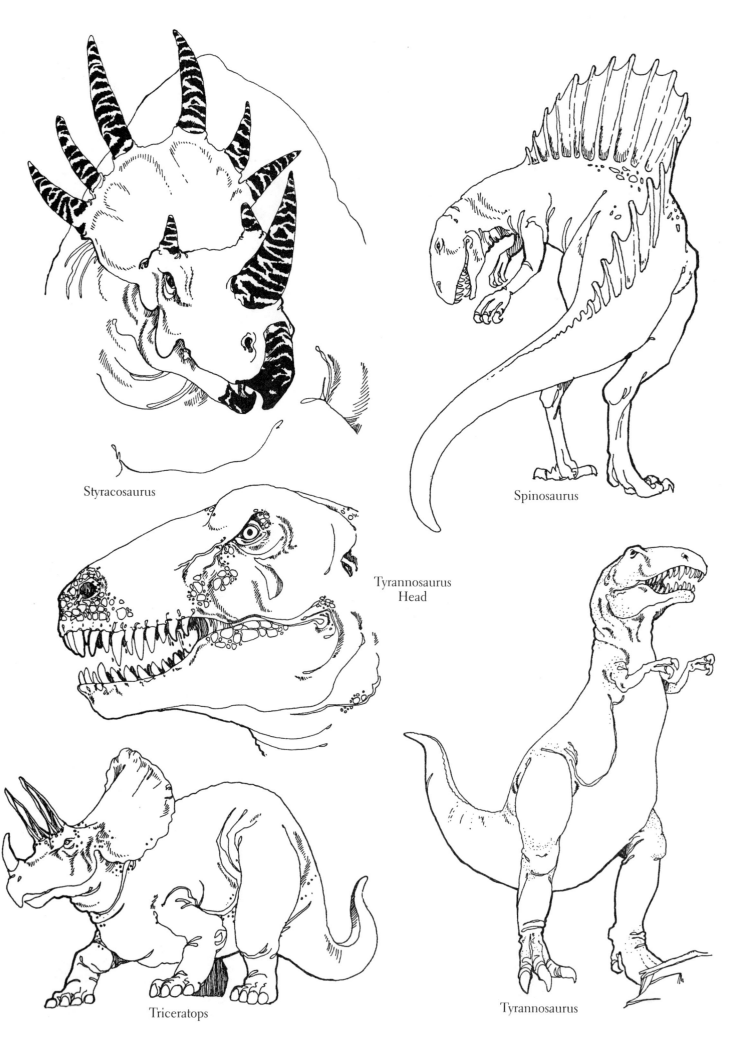

Styracosaurus

Spinosaurus

Tyrannosaurus
Head

Triceratops

Tyrannosaurus

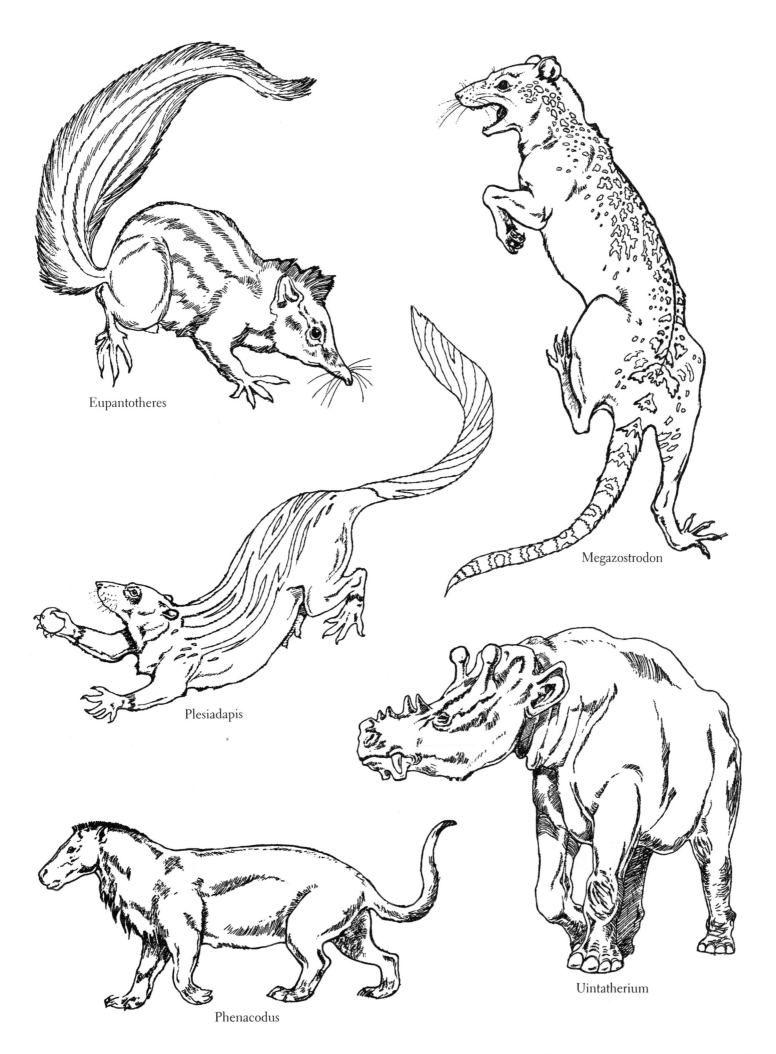

Eupantotheres

Megazostrodon

Plesiadapis

Phenacodus

Uintatherium

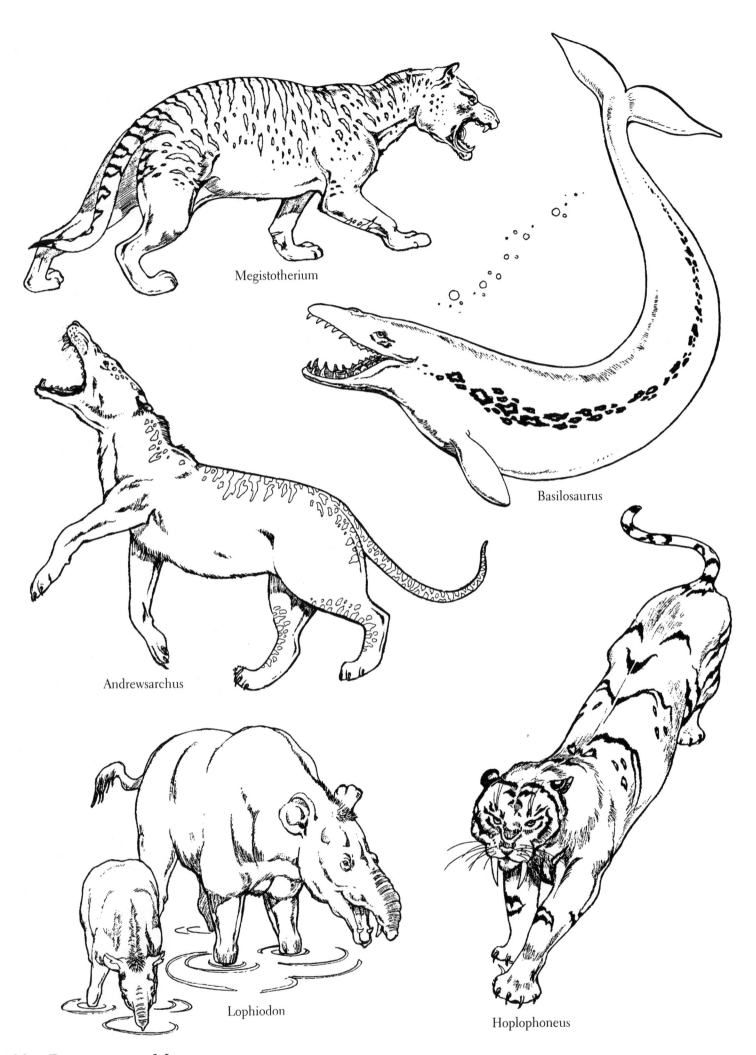

Megistotherium

Basilosaurus

Andrewsarchus

Lophiodon

Hoplophoneus

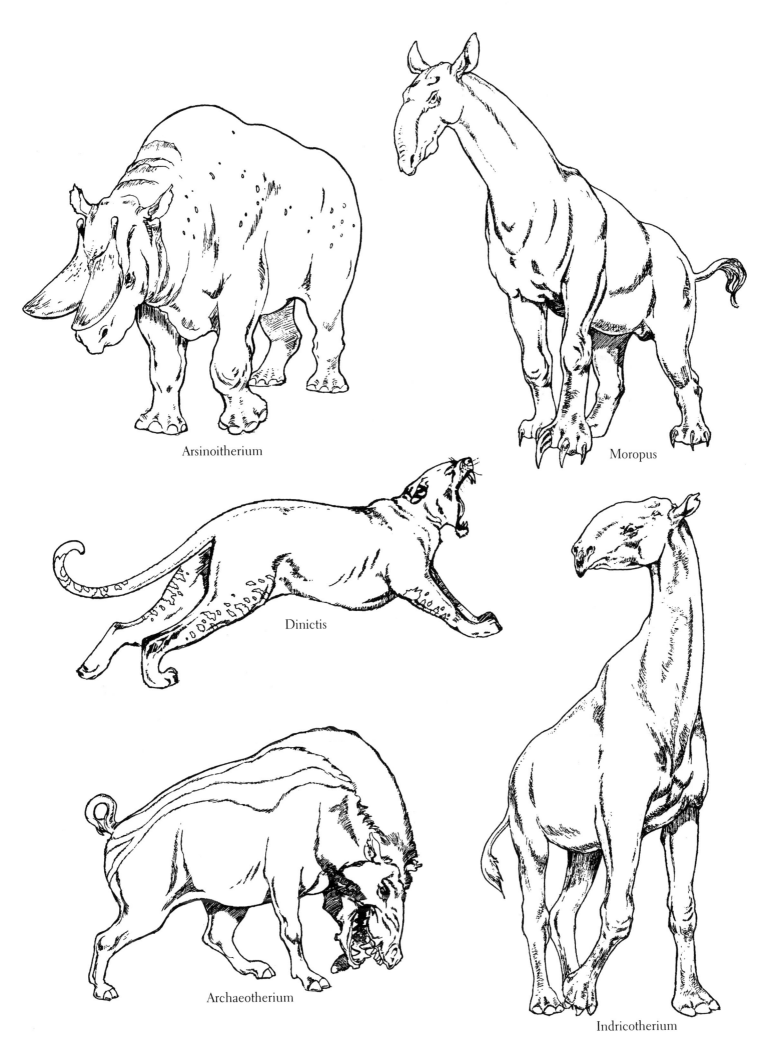

Arsinoitherium

Moropus

Dinictis

Archaeotherium

Indricotherium

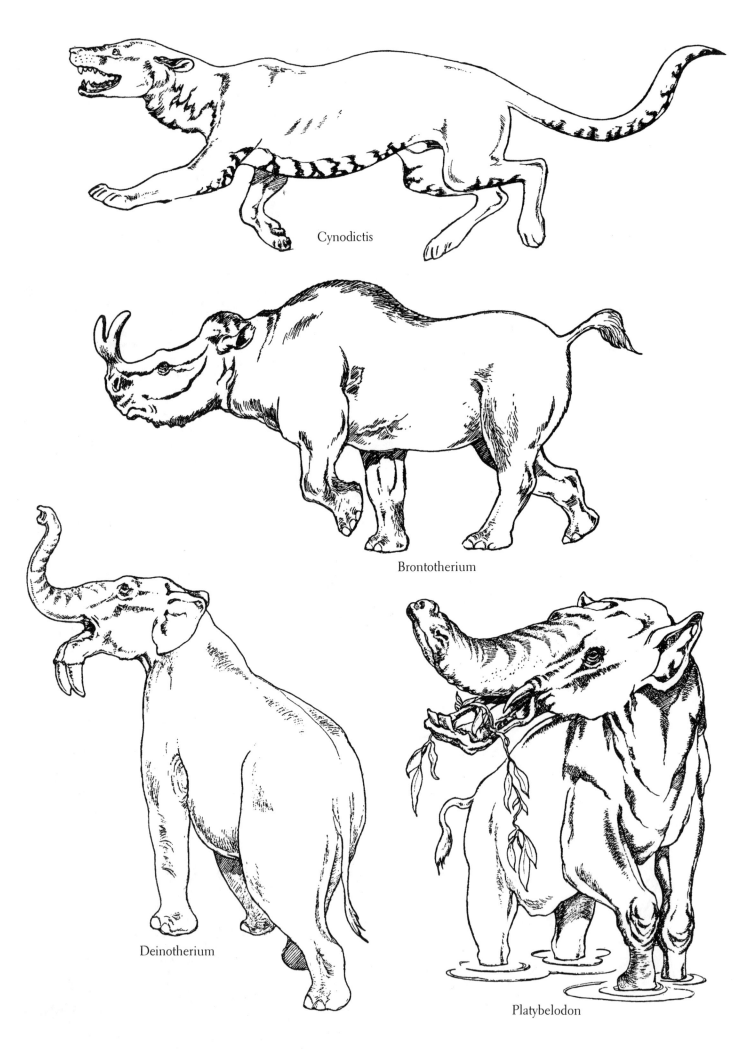

Cynodictis

Brontotherium

Deinotherium

Platybelodon

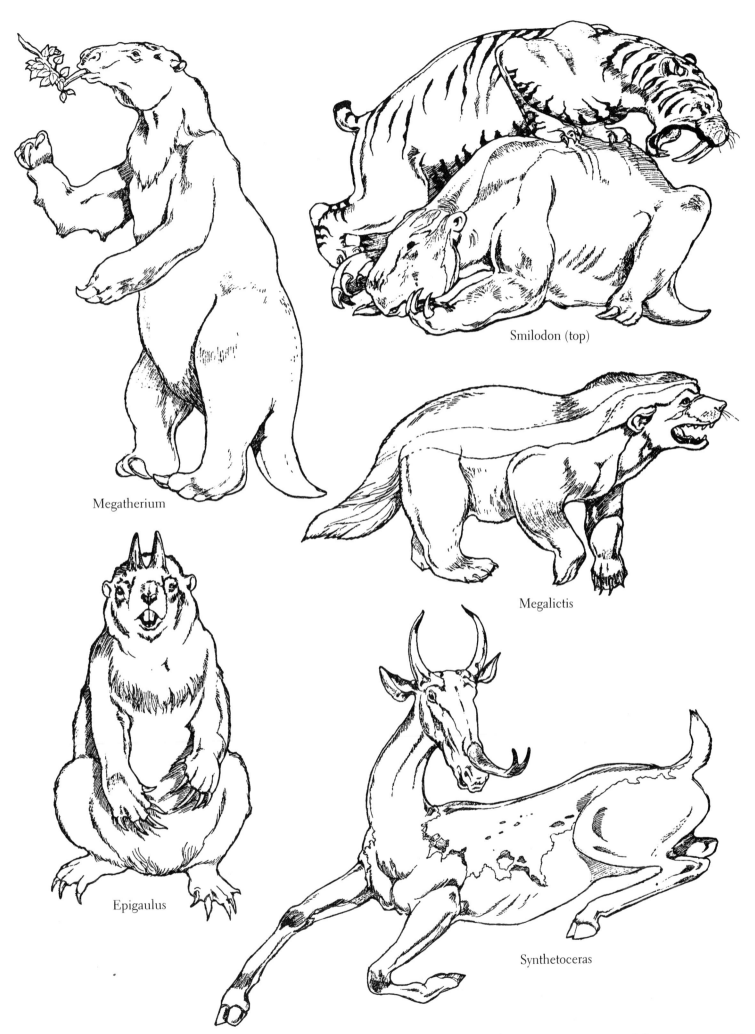

Megatherium

Smilodon (top)

Megalictis

Epigaulus

Synthetoceras

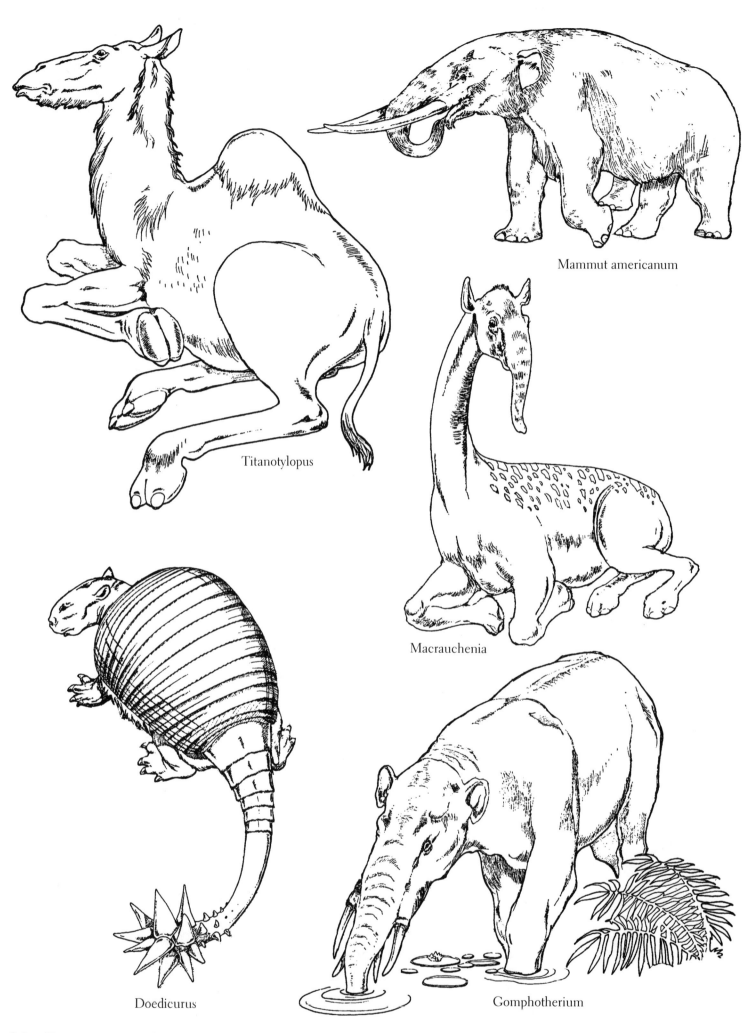

Mammut americanum

Titanotylopus

Macrauchenia

Doedicurus

Gomphotherium

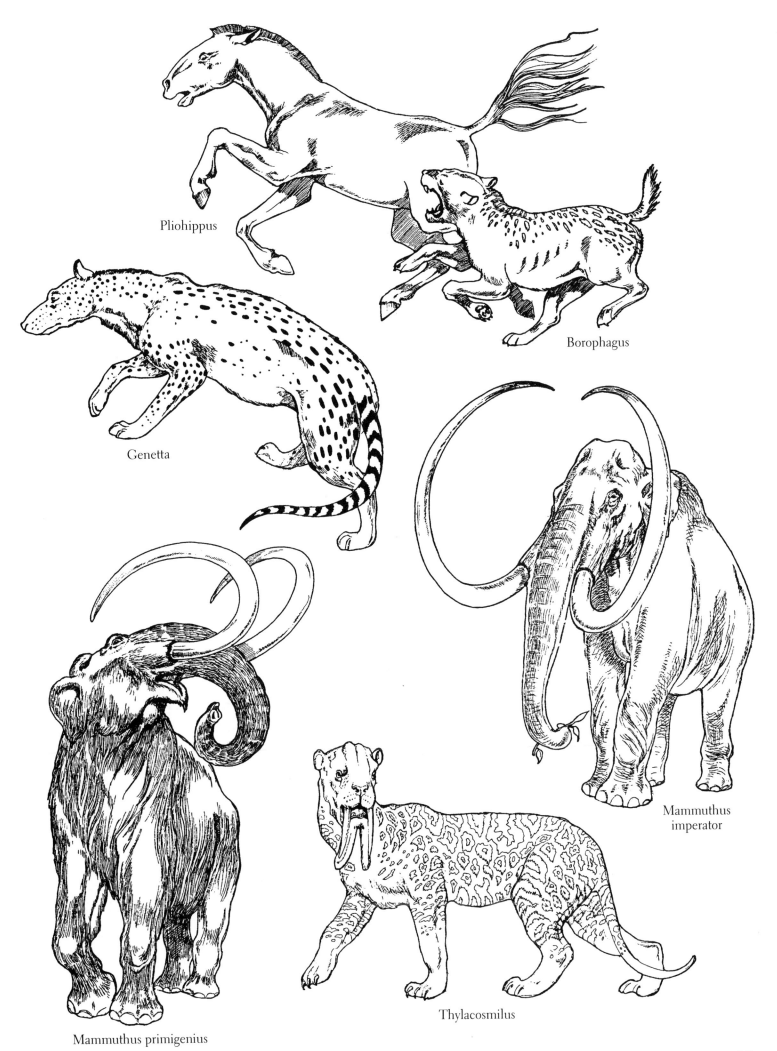

Pliohippus

Borophagus

Genetta

Mammuthus
imperator

Mammuthus primigenius

Thylacosmilus

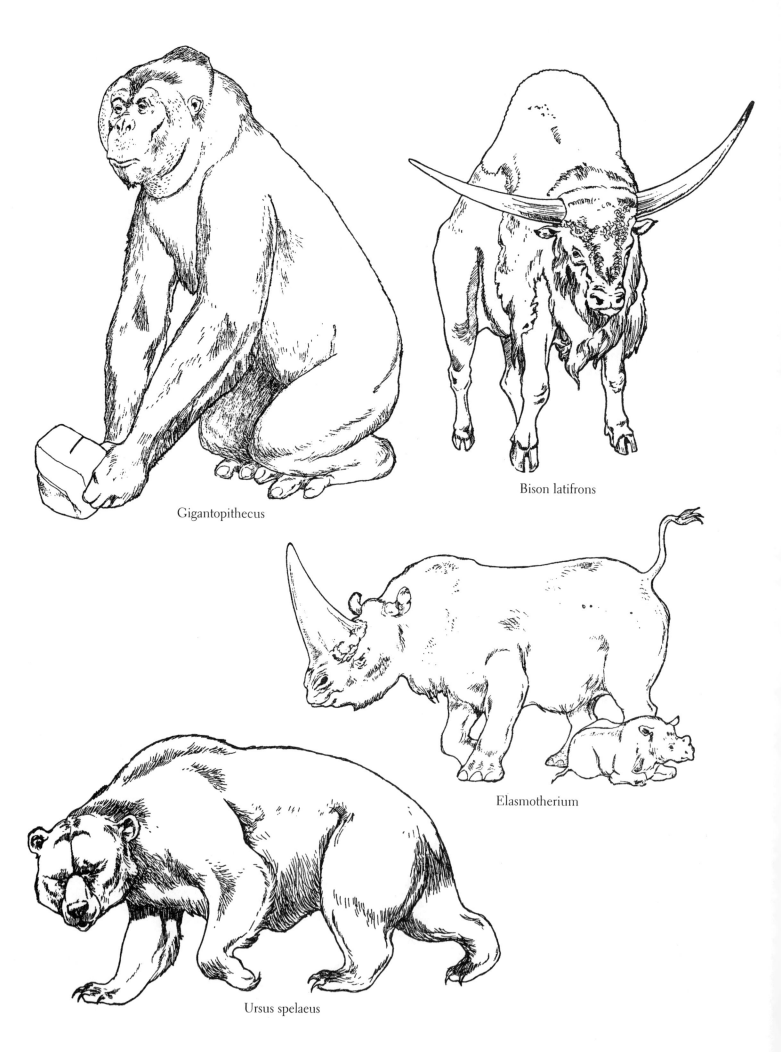

Gigantopithecus

Bison latifrons

Elasmotherium

Ursus spelaeus

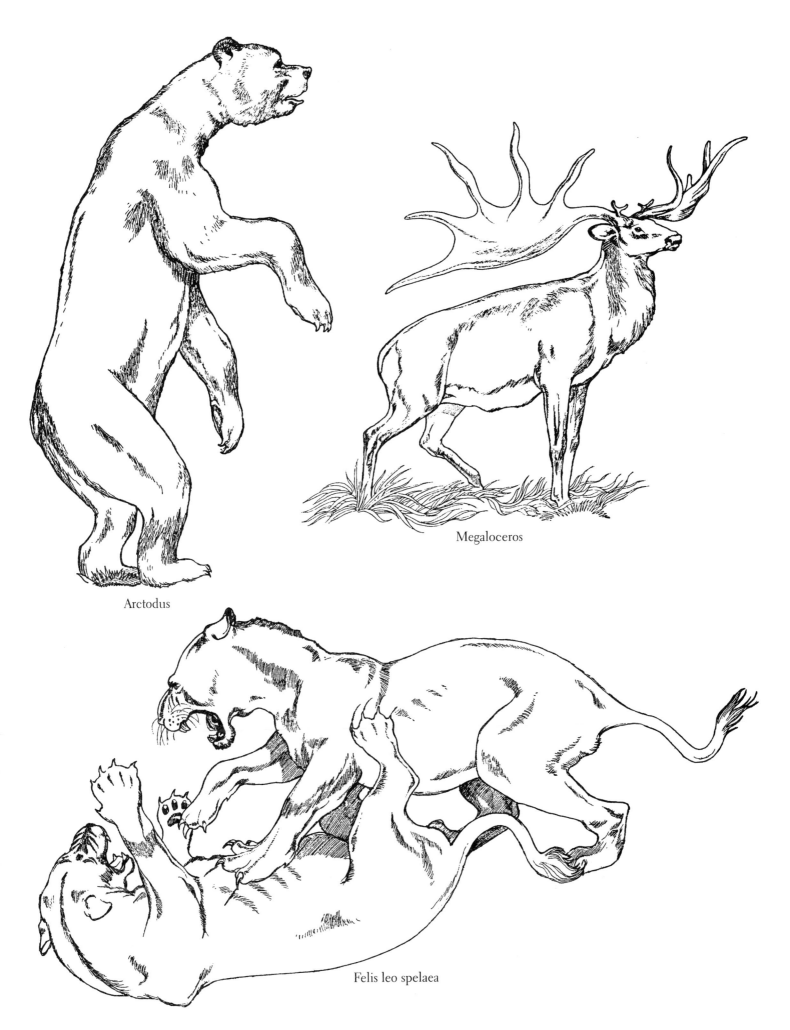

Arctodus

Megaloceros

Felis leo spelaea

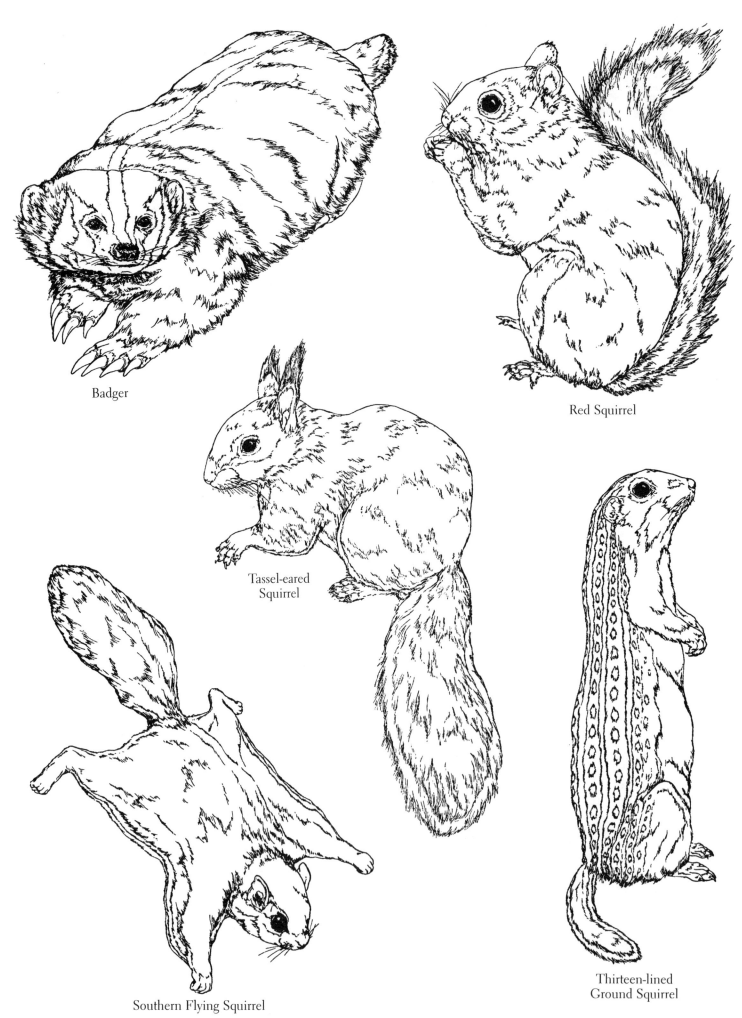

Badger

Red Squirrel

Tassel-eared
Squirrel

Southern Flying Squirrel

Thirteen-lined
Ground Squirrel

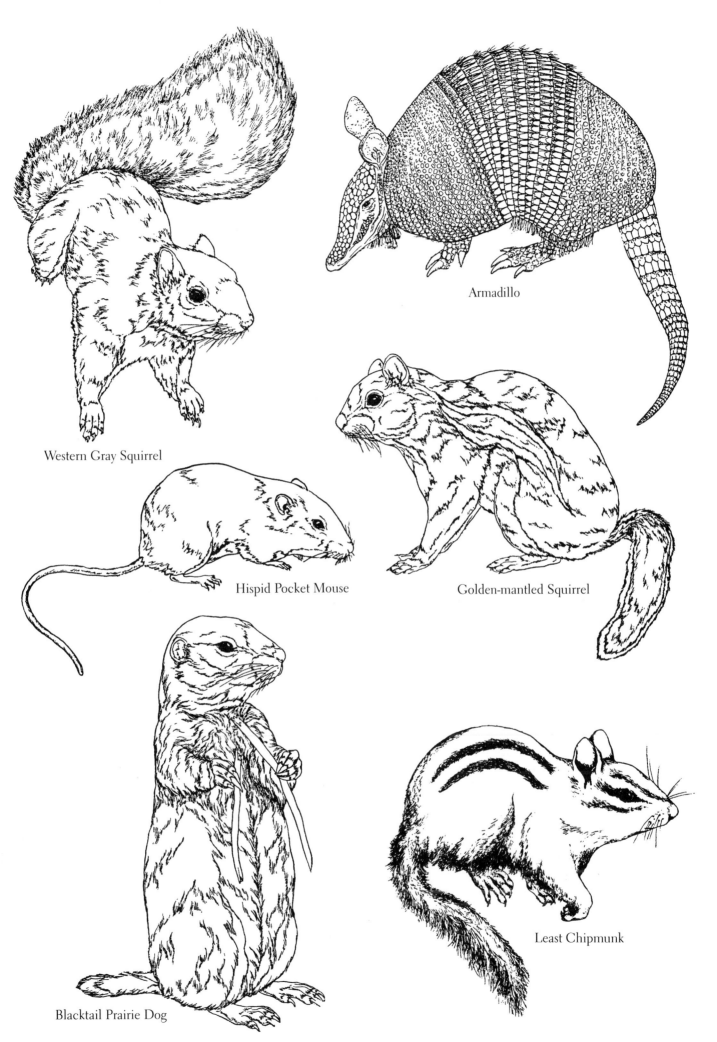

Western Gray Squirrel

Armadillo

Hispid Pocket Mouse

Golden-mantled Squirrel

Blacktail Prairie Dog

Least Chipmunk

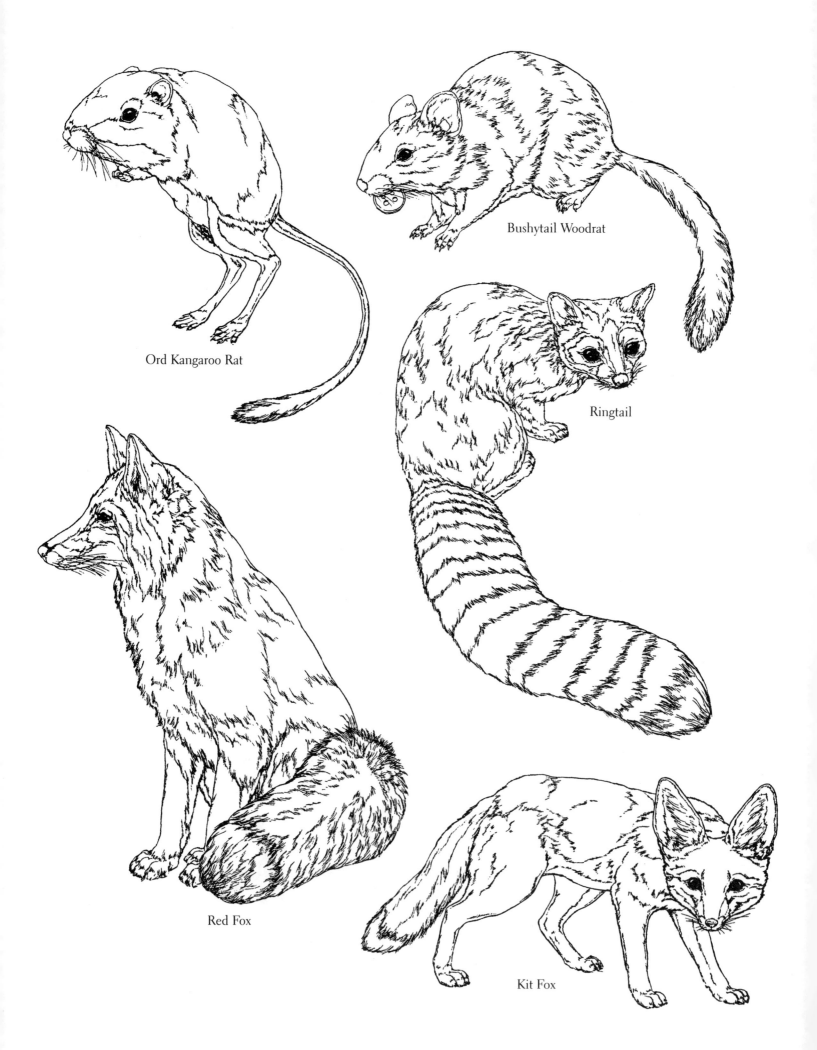

Ord Kangaroo Rat

Bushytail Woodrat

Ringtail

Red Fox

Kit Fox

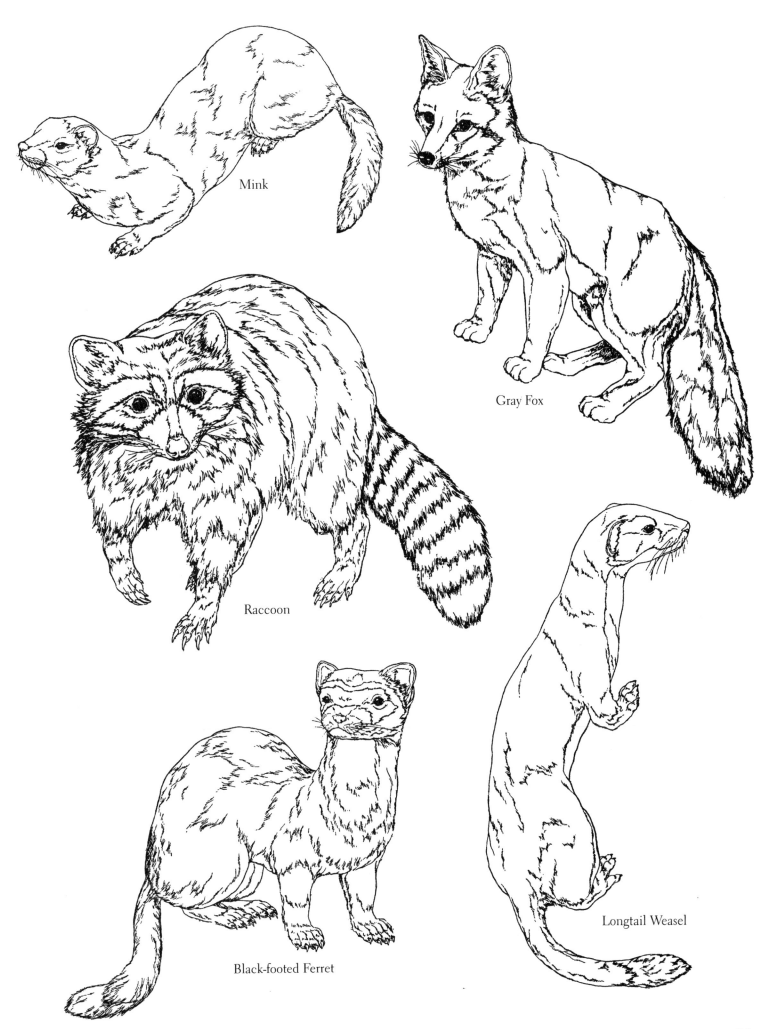

Mink

Gray Fox

Raccoon

Black-footed Ferret

Longtail Weasel

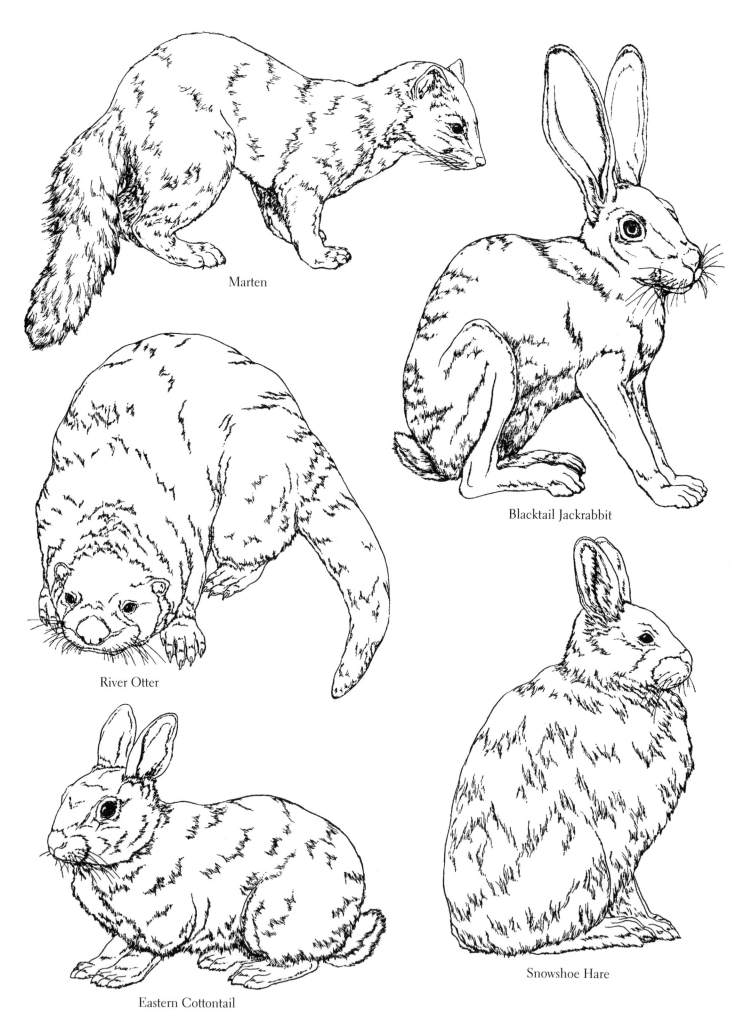

Marten

Blacktail Jackrabbit

River Otter

Eastern Cottontail

Snowshoe Hare

Eastern Mole

Muskrat

Spotted Skunk

Woodchuck

Opossum

Beaver

Deer Mouse

Striped Skunk

Pika

Yellowbelly
Marmot

Bobcat

Meadow Vole

Valley Pocket Gopher

Western Harvest Mouse

Big Brown Bat

Peccary

Southern Bog Lemming

Shorttail Shrew

Coyote

Porcupine

Polar Bear

Black Bear

Brown Bear

Mountain Goat

Muskox

Puma

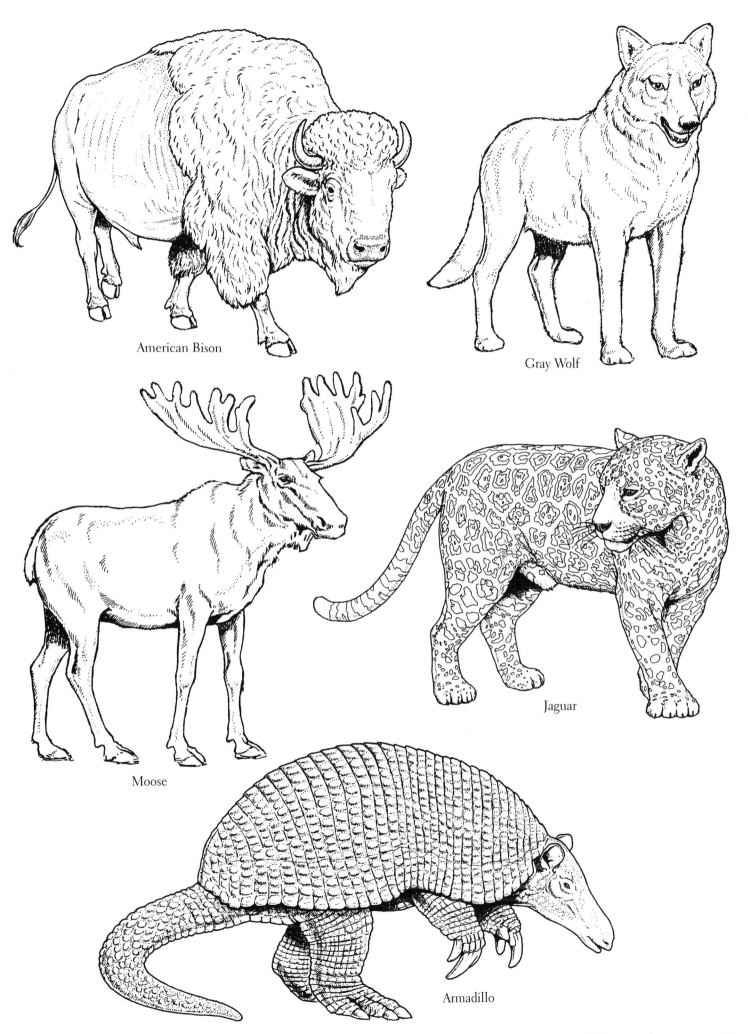

American Bison

Gray Wolf

Moose

Jaguar

Armadillo

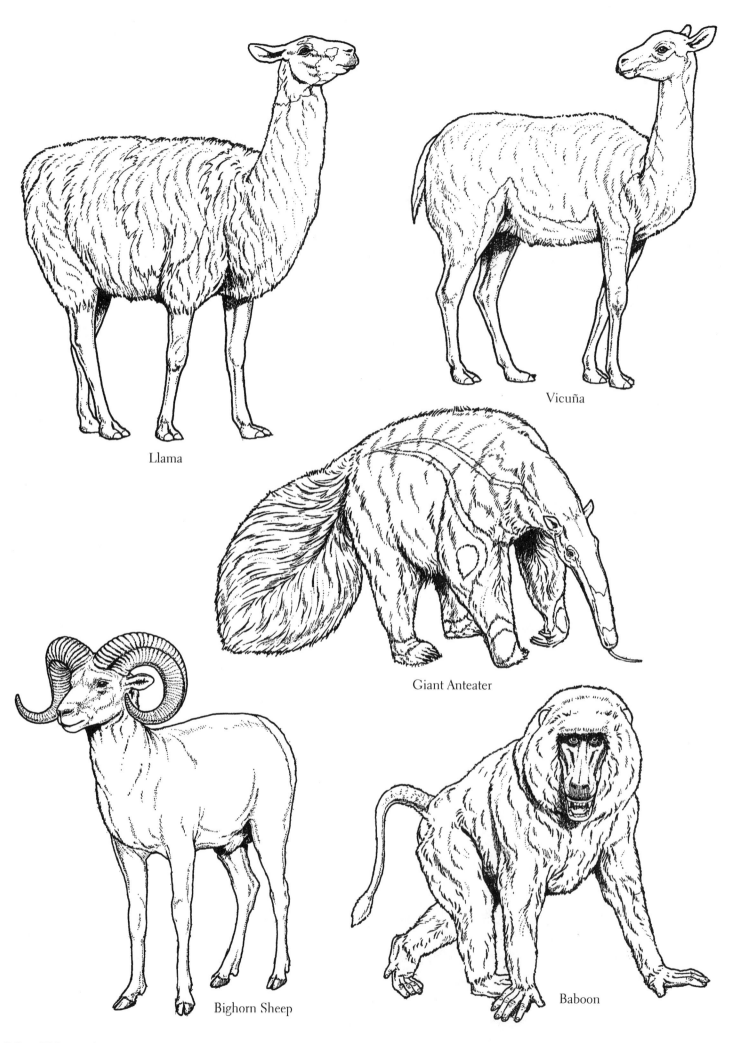

Llama

Vicuña

Giant Anteater

Bighorn Sheep

Baboon

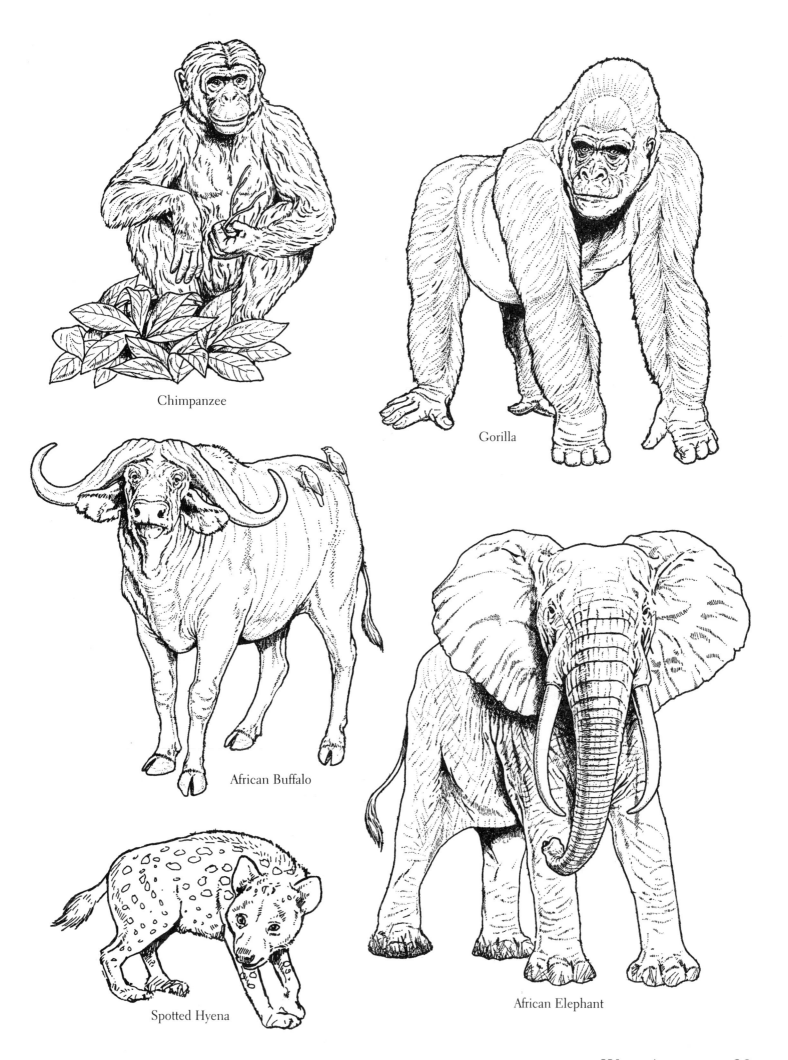

Chimpanzee

Gorilla

African Buffalo

African Elephant

Spotted Hyena

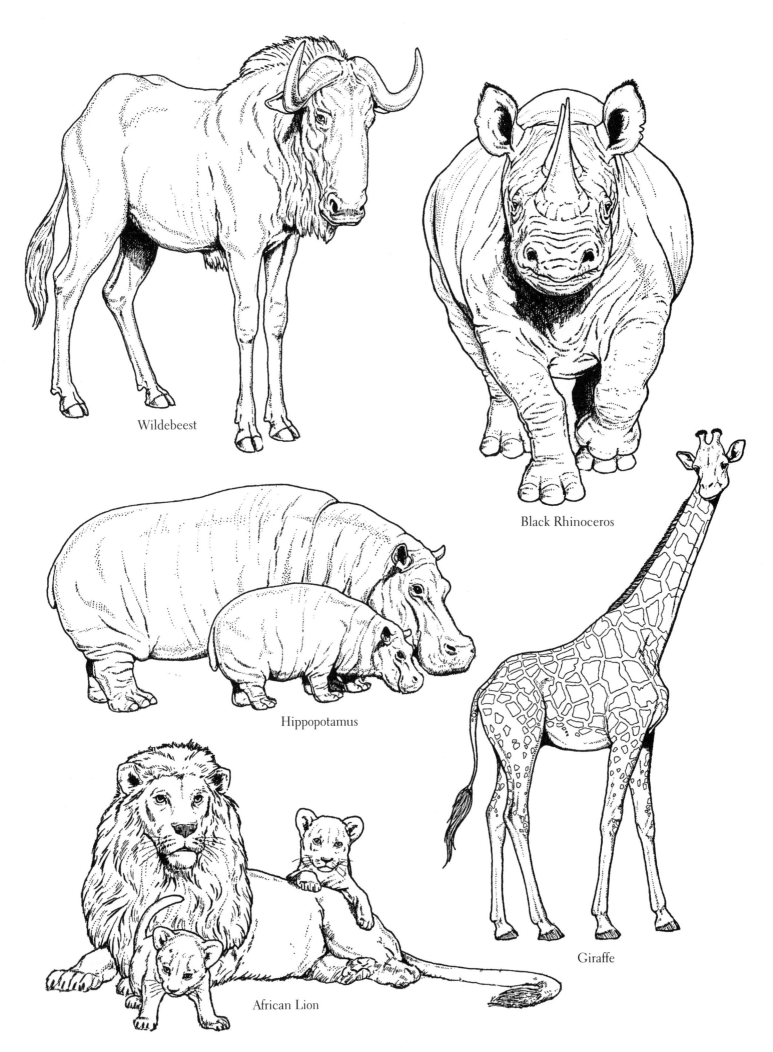

Wildebeest

Black Rhinoceros

Hippopotamus

Giraffe

African Lion

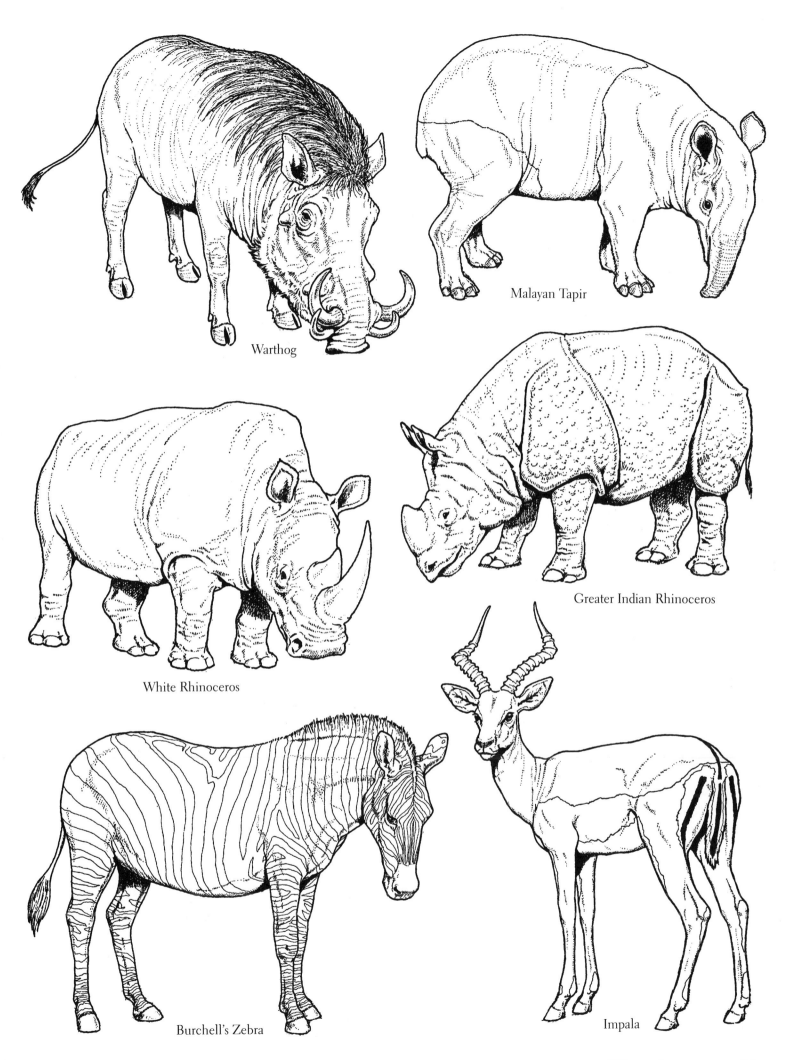

Warthog

Malayan Tapir

White Rhinoceros

Greater Indian Rhinoceros

Burchell's Zebra

Impala

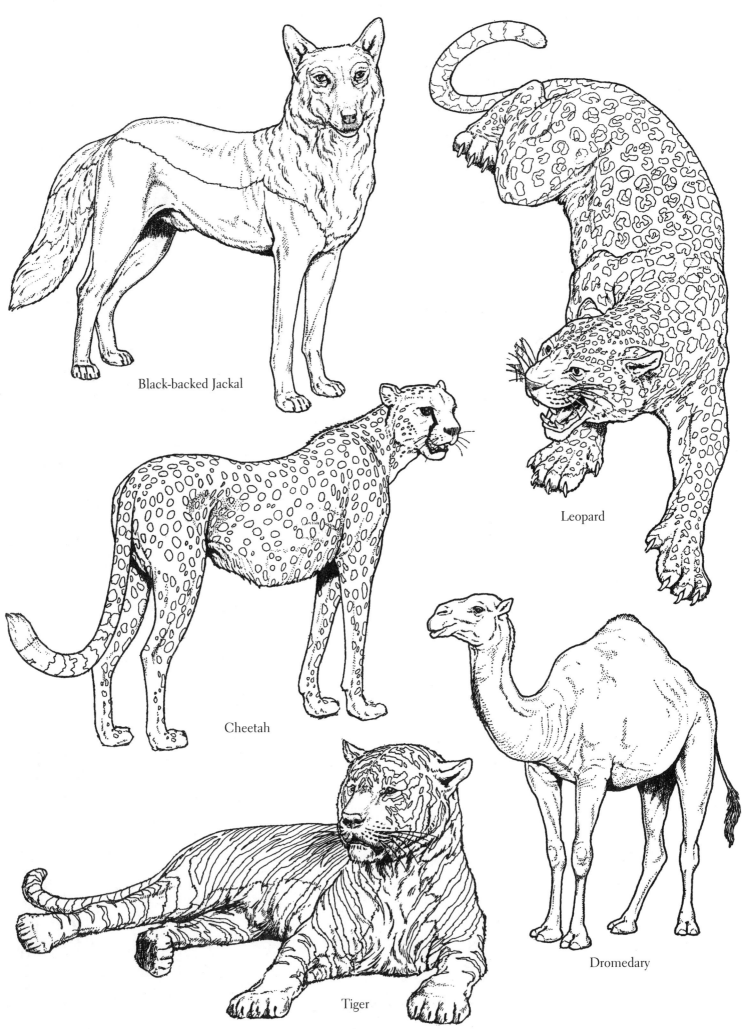

Black-backed Jackal

Leopard

Cheetah

Dromedary

Tiger

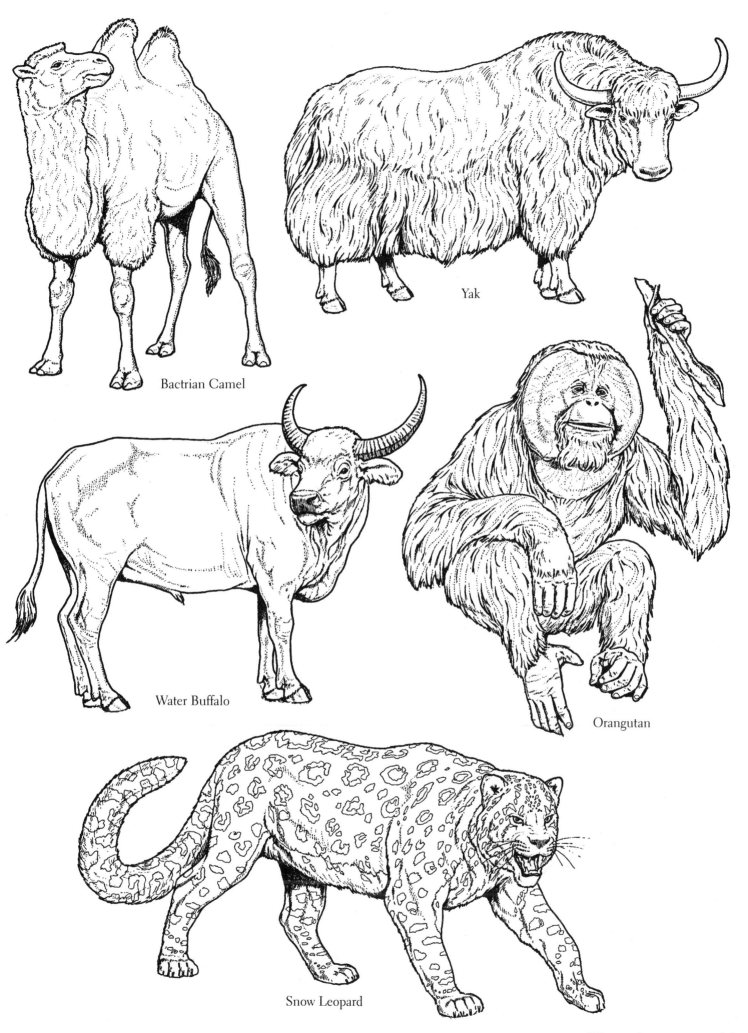

Bactrian Camel

Yak

Water Buffalo

Orangutan

Snow Leopard

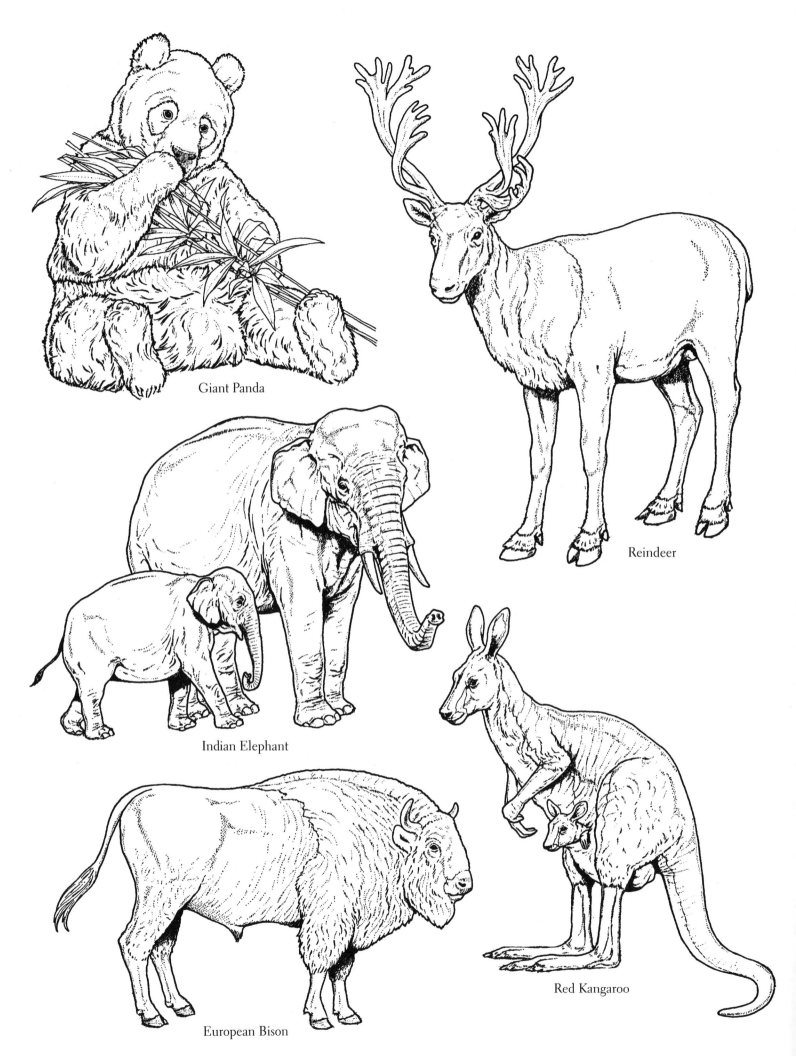

Giant Panda

Reindeer

Indian Elephant

Red Kangaroo

European Bison

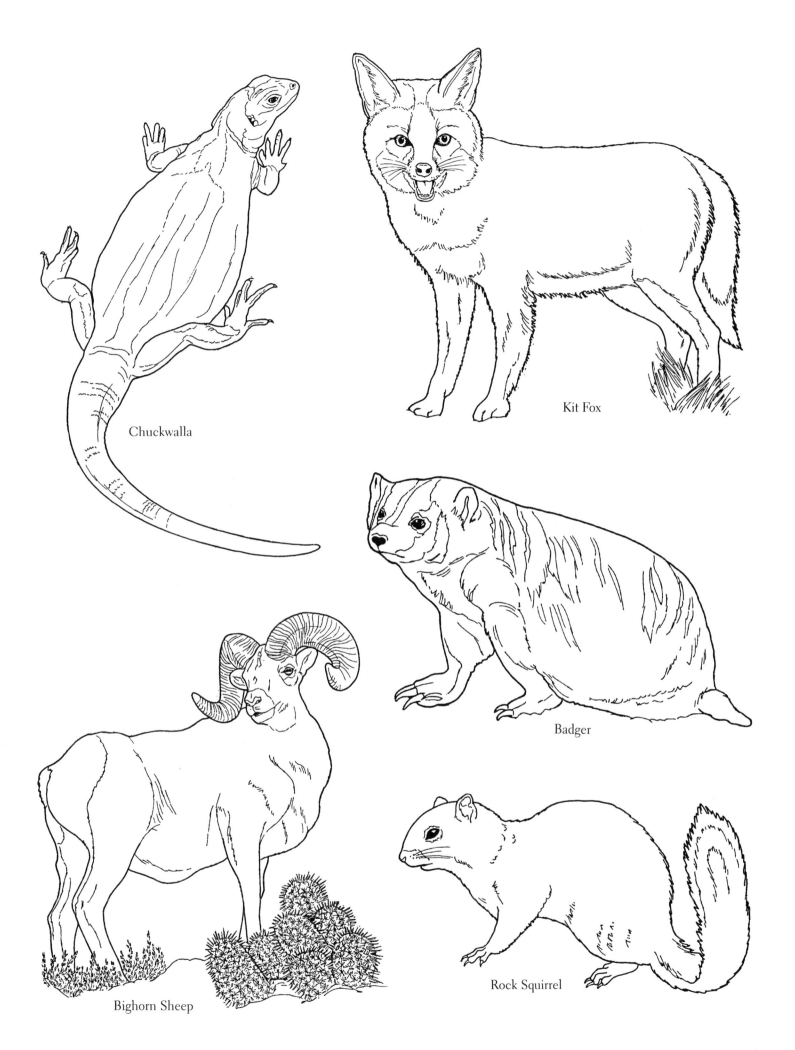

Chuckwalla

Kit Fox

Badger

Bighorn Sheep

Rock Squirrel

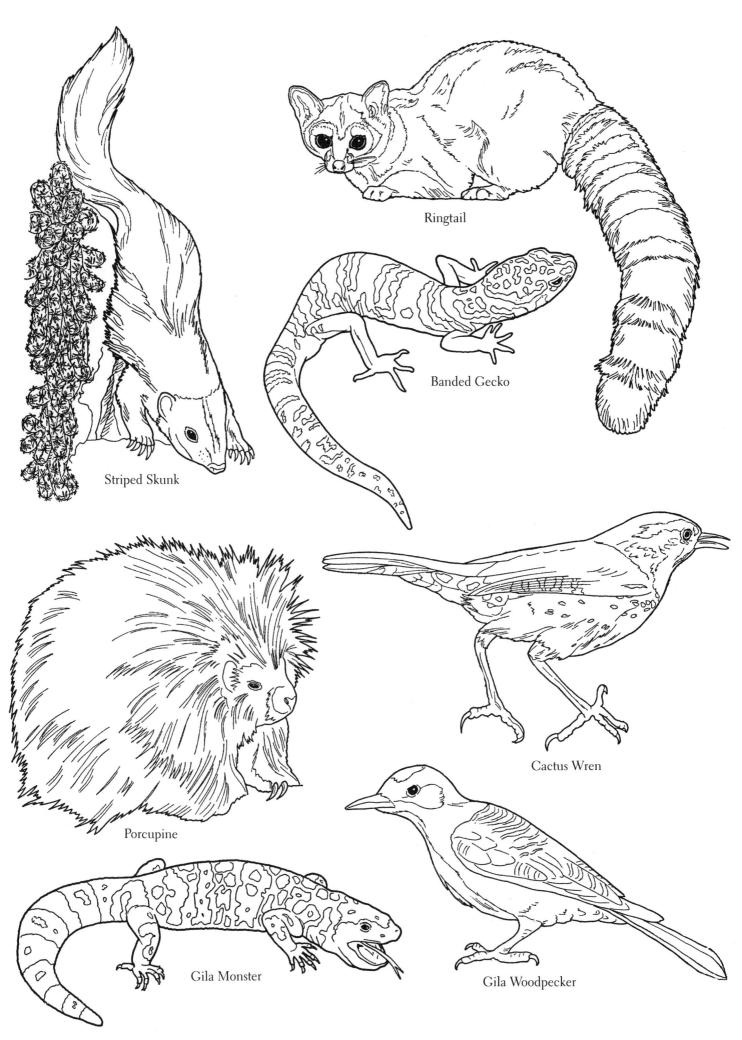

Ringtail

Banded Gecko

Striped Skunk

Porcupine

Cactus Wren

Gila Monster

Gila Woodpecker

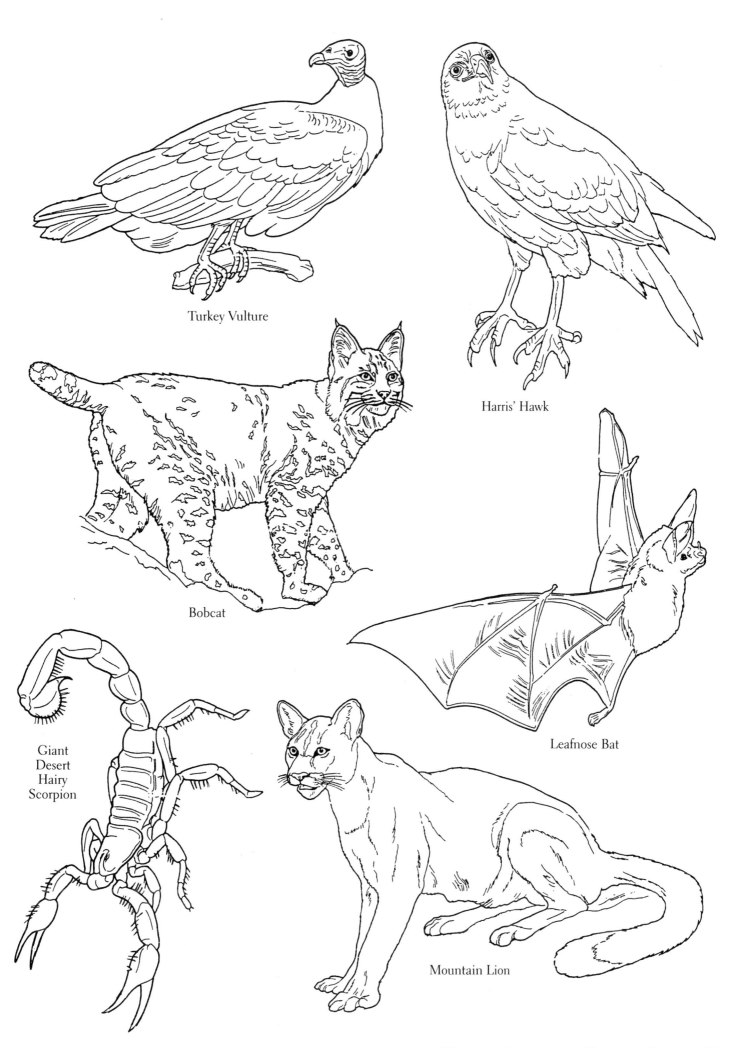

Turkey Vulture

Harris' Hawk

Bobcat

Leafnose Bat

Giant Desert Hairy Scorpion

Mountain Lion

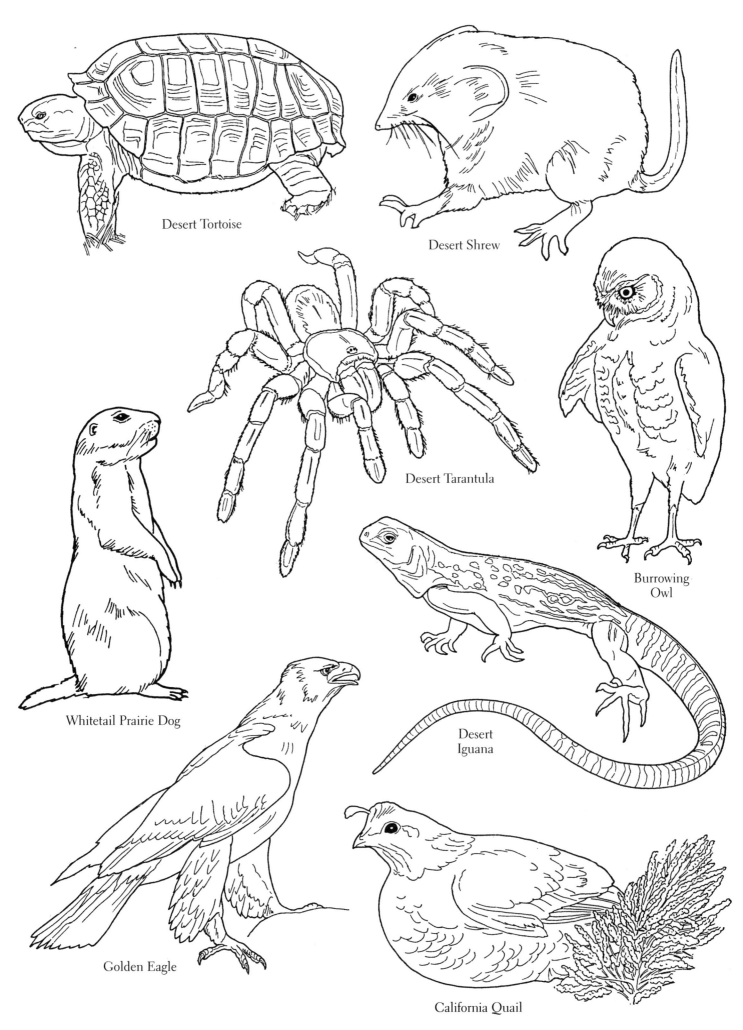

Desert Tortoise

Desert Shrew

Desert Tarantula

Burrowing Owl

Whitetail Prairie Dog

Desert Iguana

Golden Eagle

California Quail

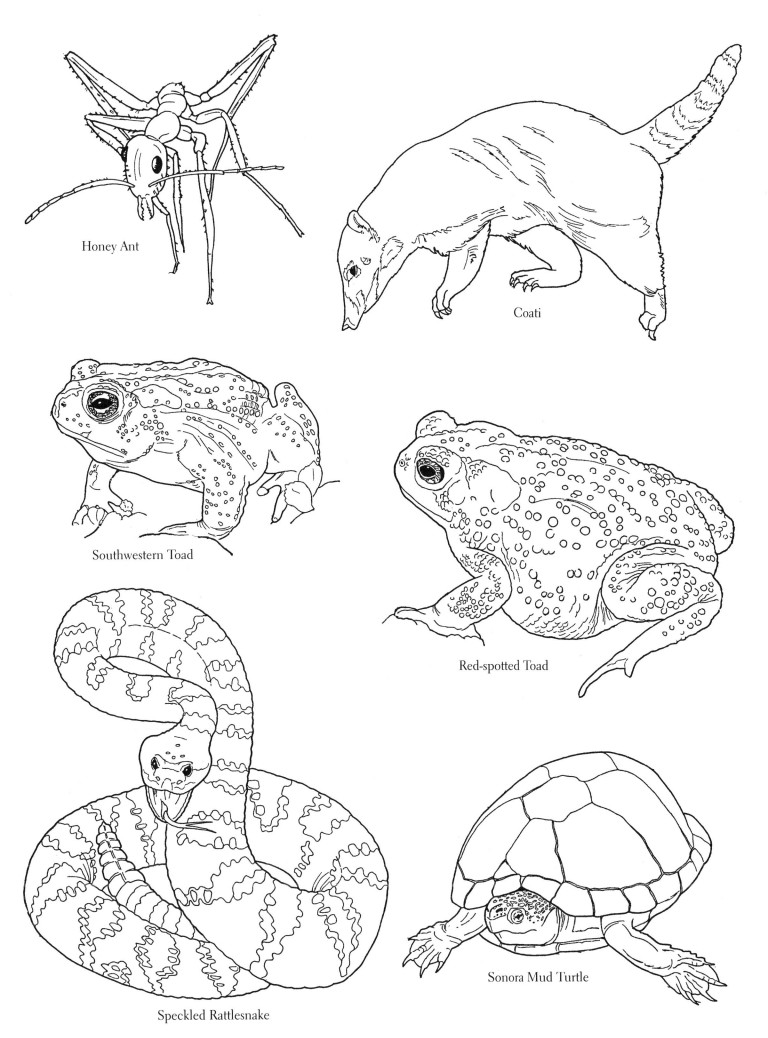

Honey Ant

Coati

Southwestern Toad

Red-spotted Toad

Speckled Rattlesnake

Sonora Mud Turtle

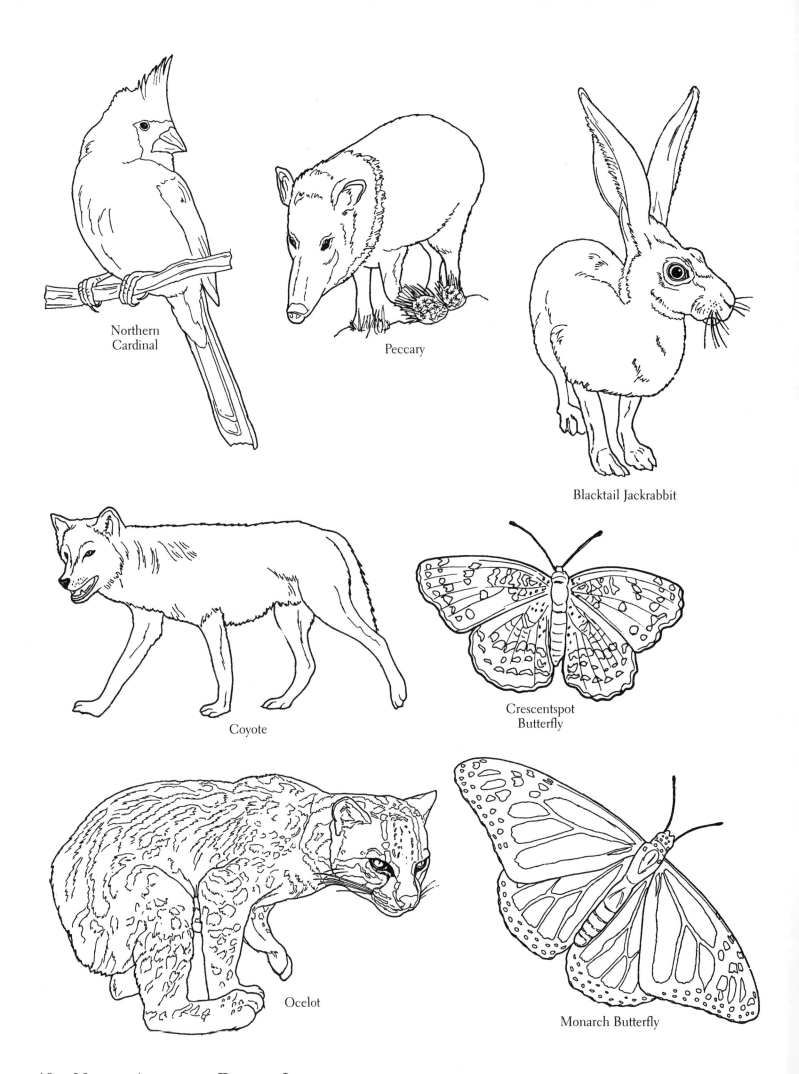

Northern
Cardinal

Peccary

Blacktail Jackrabbit

Coyote

Crescentspot
Butterfly

Ocelot

Monarch Butterfly

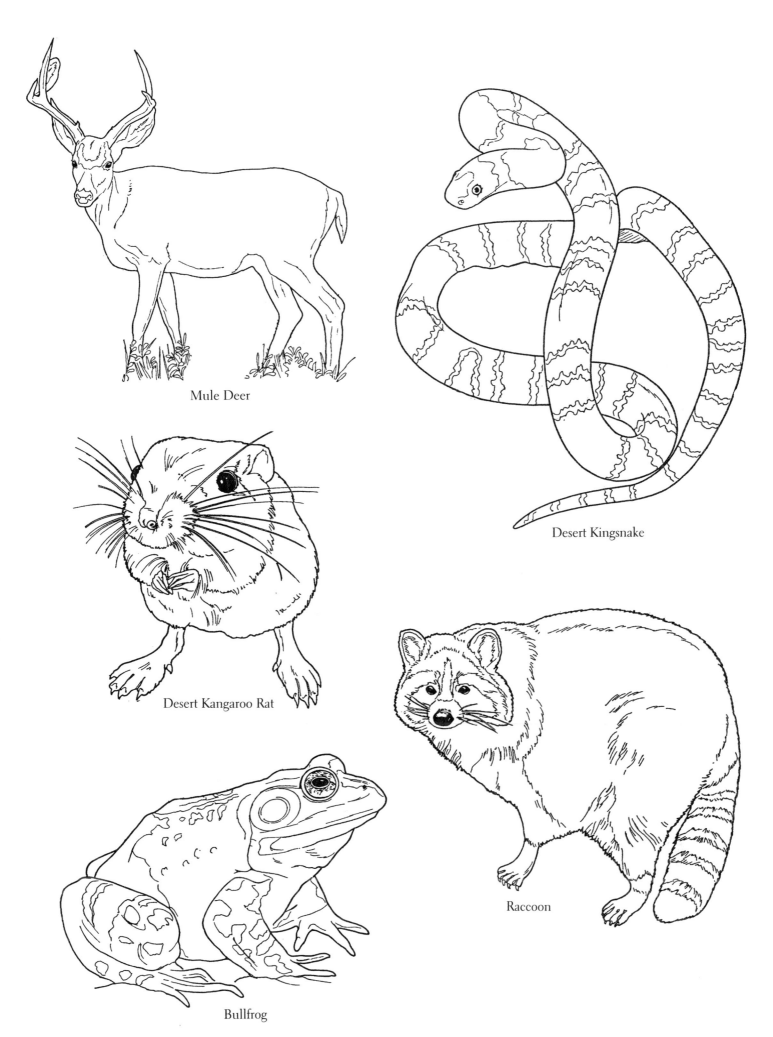

Mule Deer

Desert Kingsnake

Desert Kangaroo Rat

Raccoon

Bullfrog

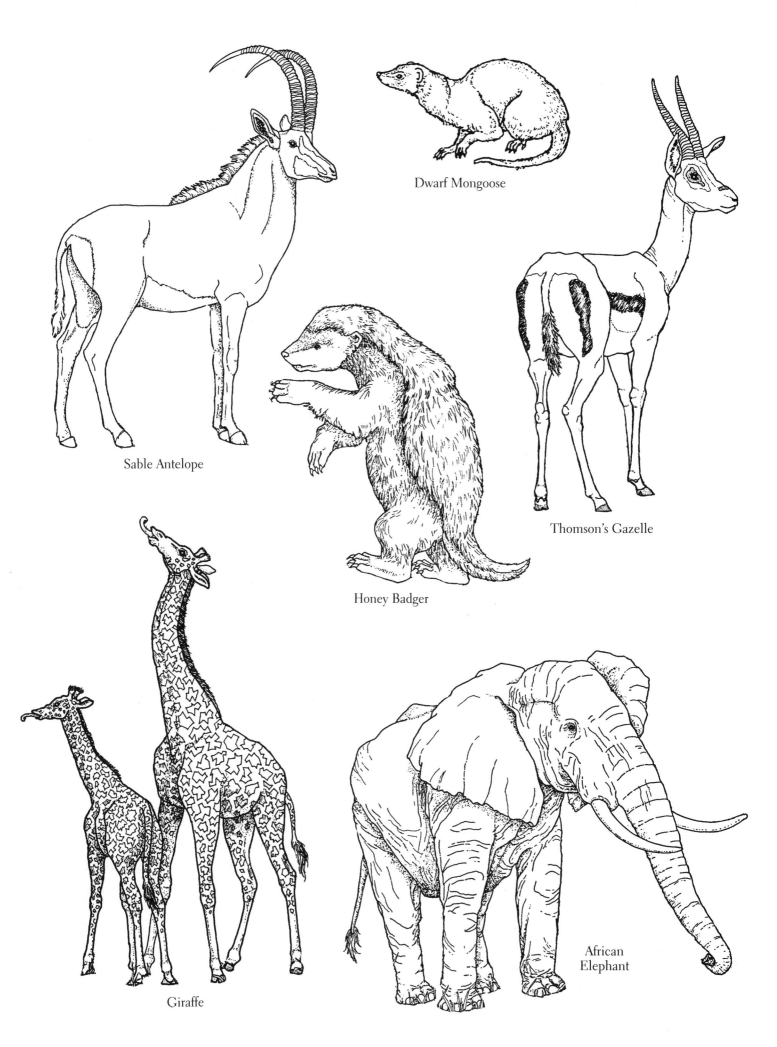

Dwarf Mongoose

Sable Antelope

Thomson's Gazelle

Honey Badger

Giraffe

African
Elephant

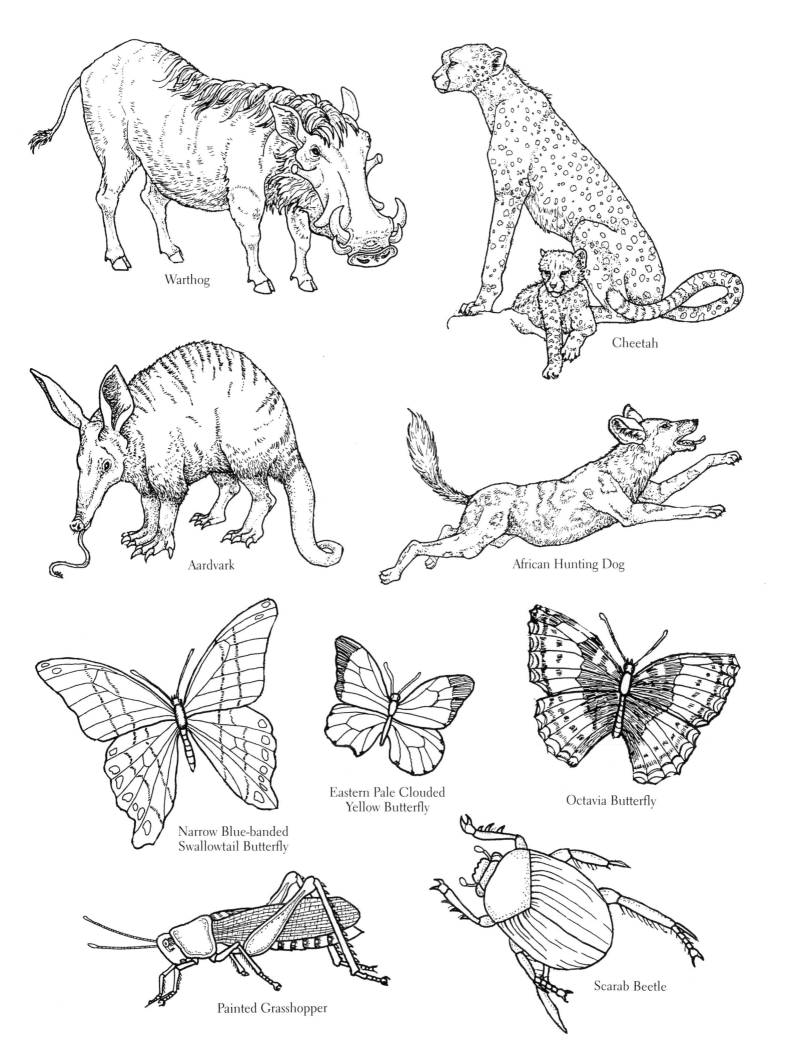

Warthog

Cheetah

Aardvark

African Hunting Dog

Narrow Blue-banded
Swallowtail Butterfly

Eastern Pale Clouded
Yellow Butterfly

Octavia Butterfly

Painted Grasshopper

Scarab Beetle

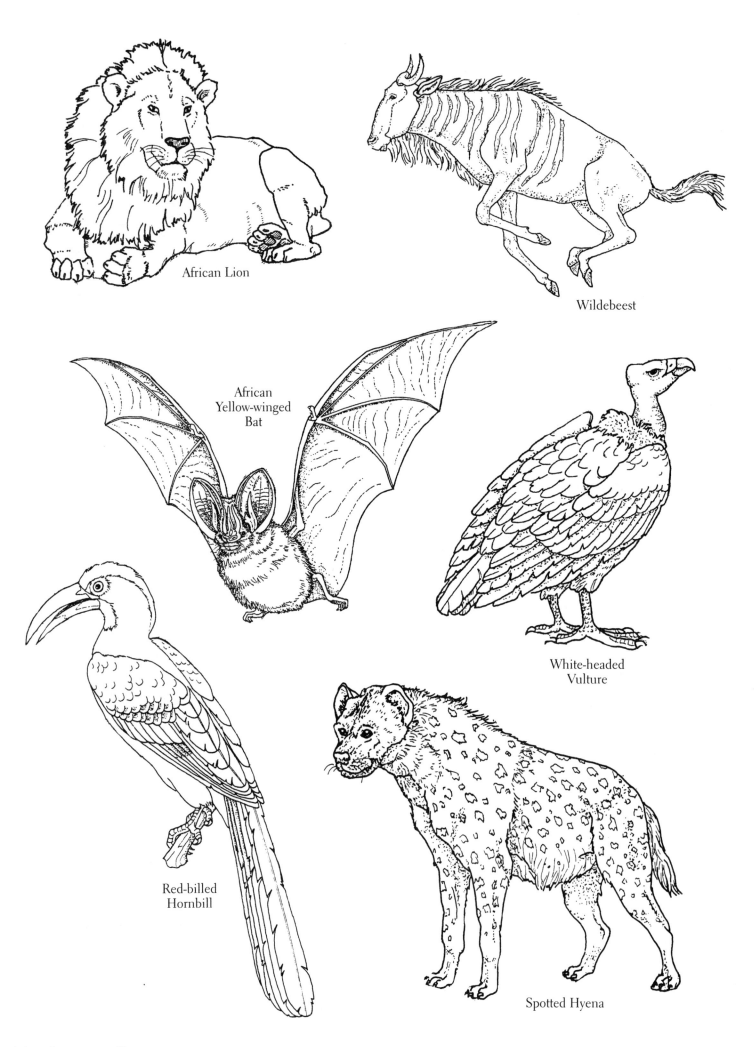

African Lion

Wildebeest

African
Yellow-winged
Bat

White-headed
Vulture

Red-billed
Hornbill

Spotted Hyena

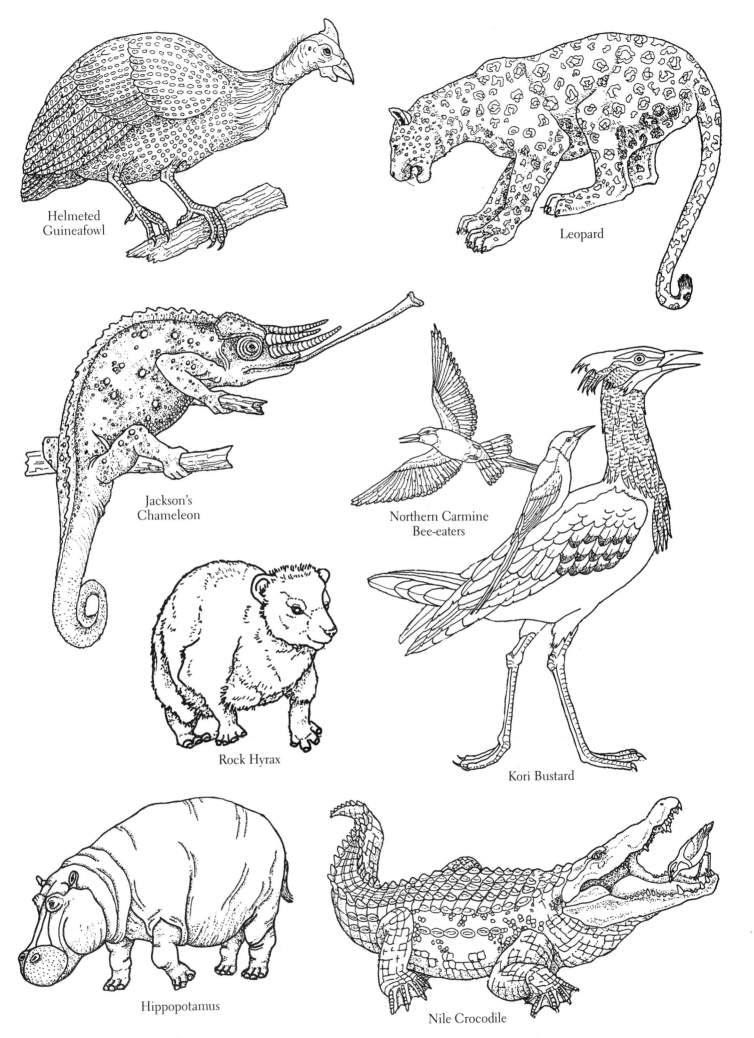

Helmeted
Guineafowl

Leopard

Jackson's
Chameleon

Northern Carmine
Bee-eaters

Rock Hyrax

Kori Bustard

Hippopotamus

Nile Crocodile

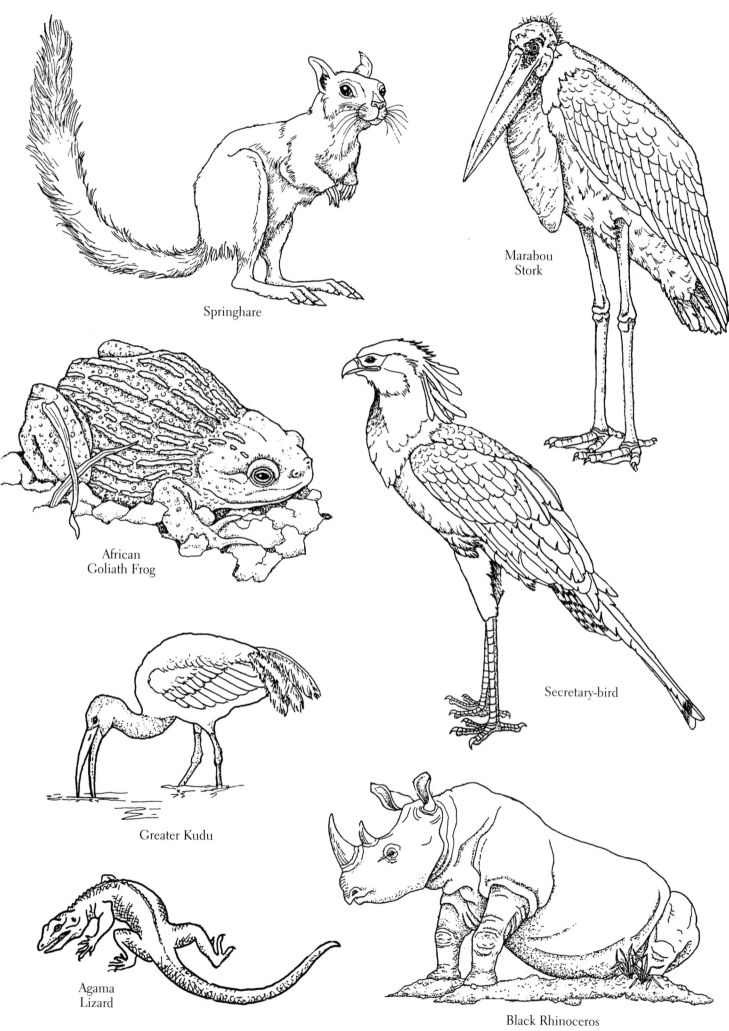

Springhare

Marabou
Stork

African
Goliath Frog

Secretary-bird

Greater Kudu

Agama
Lizard

Black Rhinoceros

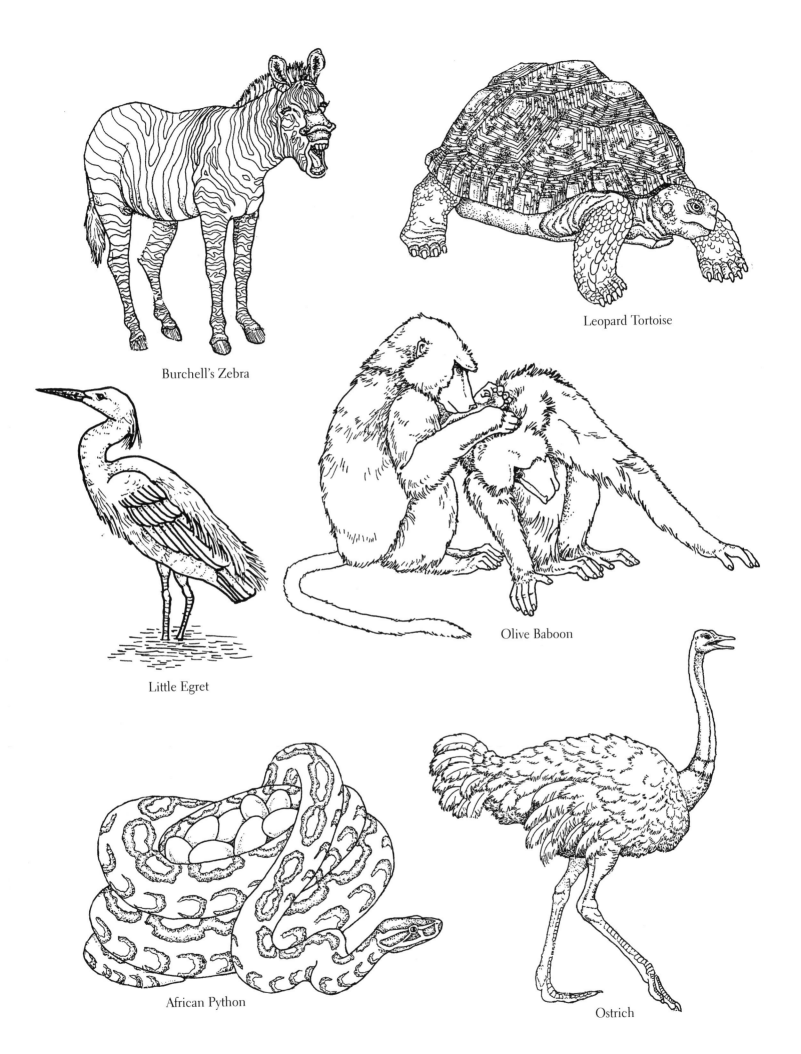

Burchell's Zebra

Leopard Tortoise

Little Egret

Olive Baboon

African Python

Ostrich

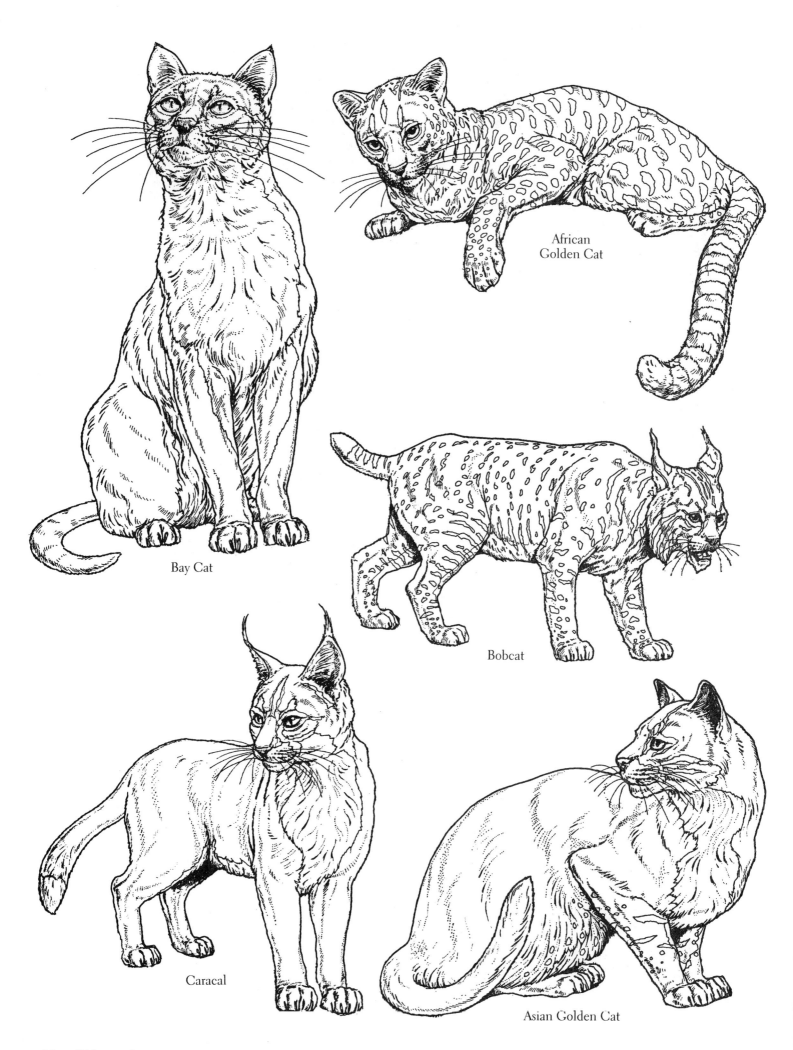

African
Golden Cat

Bay Cat

Bobcat

Caracal

Asian Golden Cat

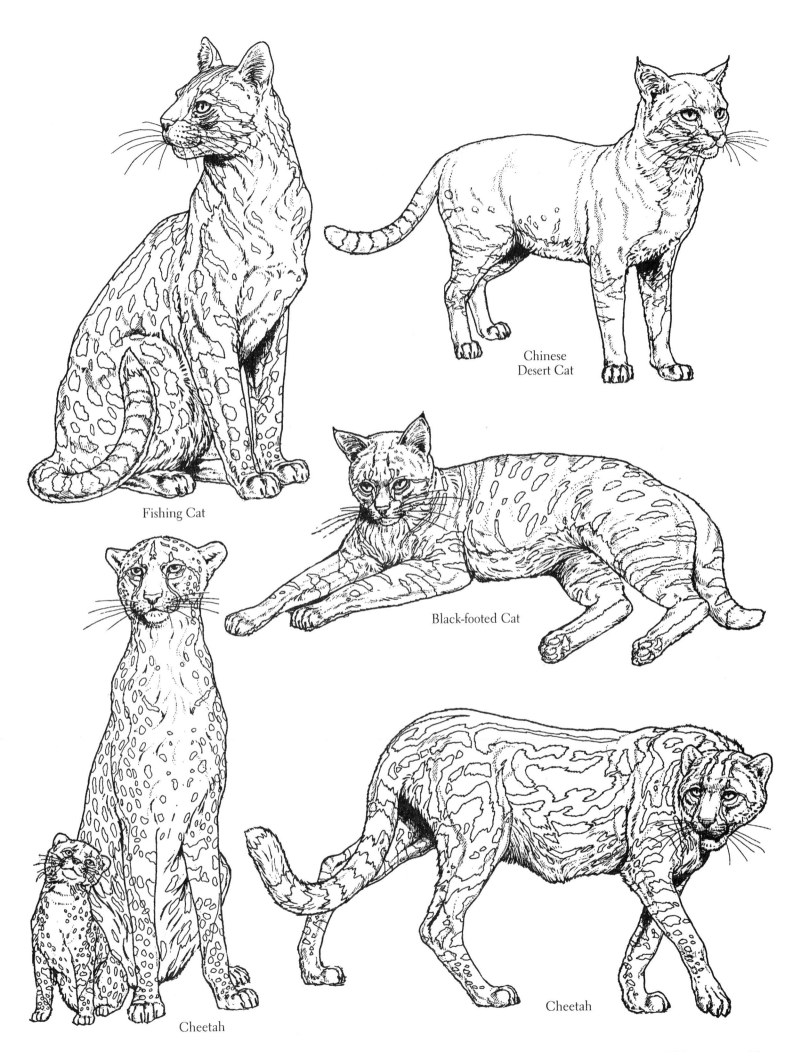

Fishing Cat

Chinese
Desert Cat

Black-footed Cat

Cheetah

Cheetah

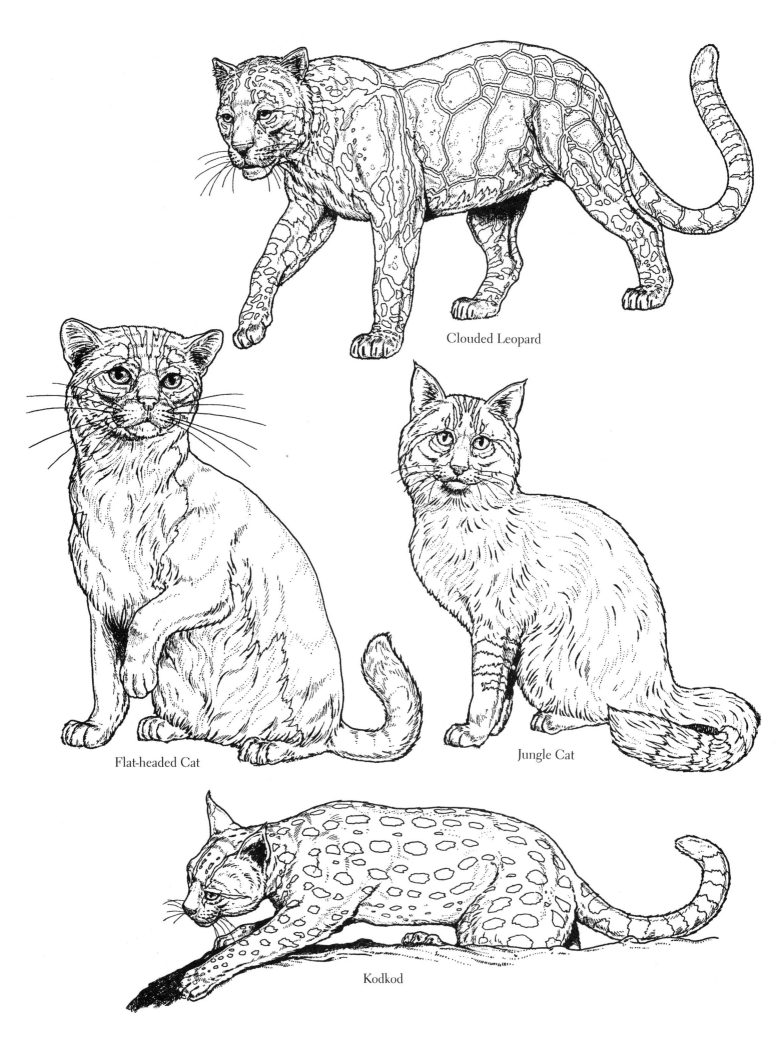

Clouded Leopard

Flat-headed Cat

Jungle Cat

Kodkod

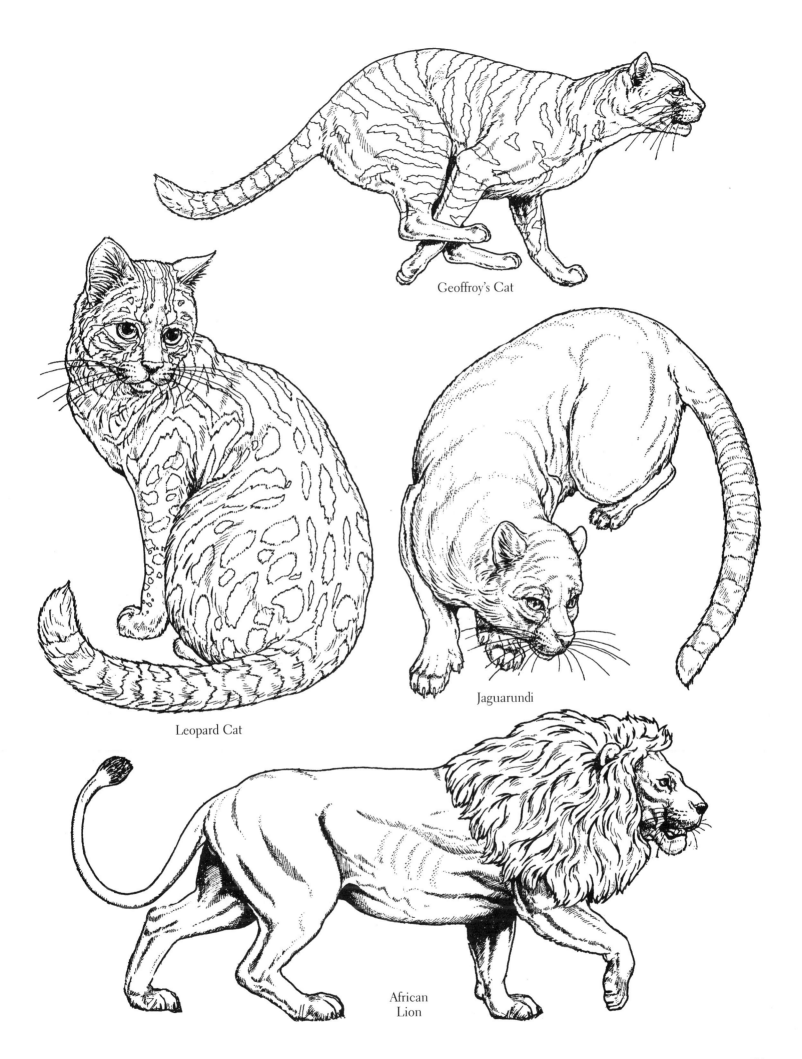

Geoffroy's Cat

Leopard Cat

Jaguarundi

African
Lion

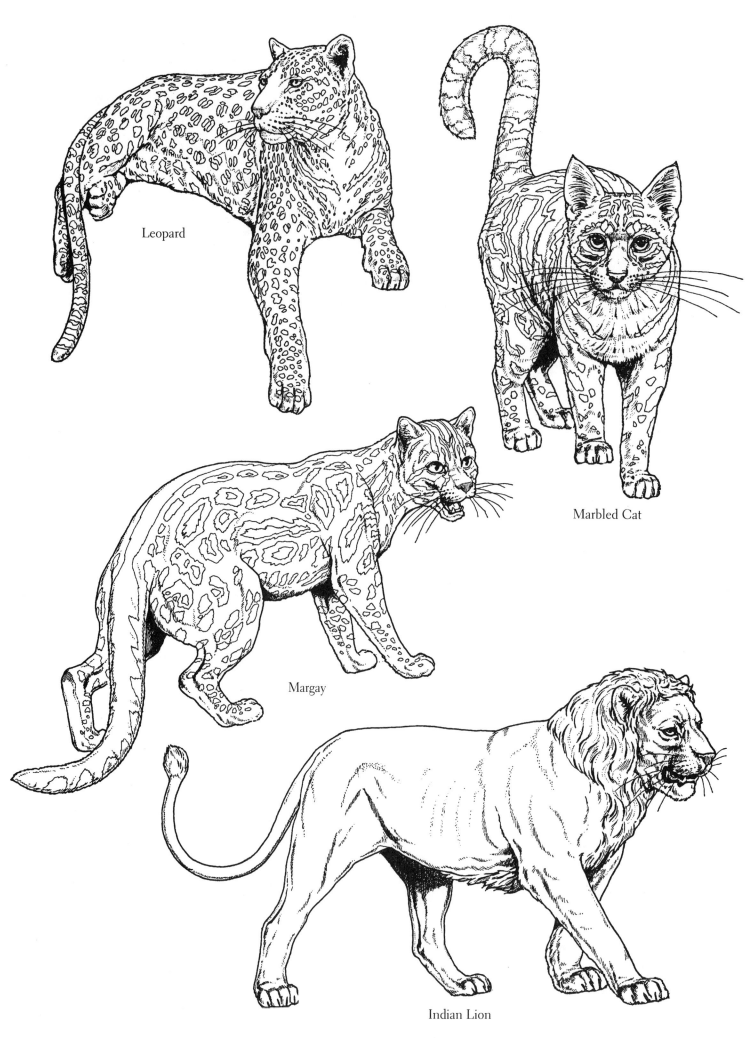

Leopard

Marbled Cat

Margay

Indian Lion

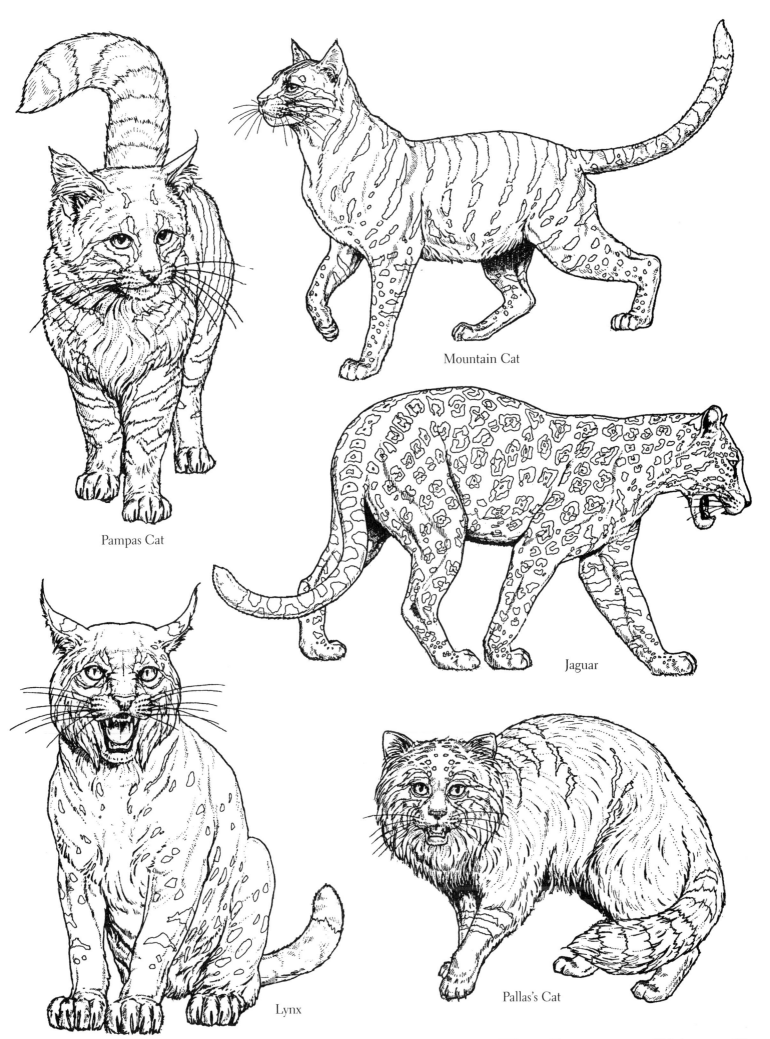

Pampas Cat

Mountain Cat

Jaguar

Lynx

Pallas's Cat

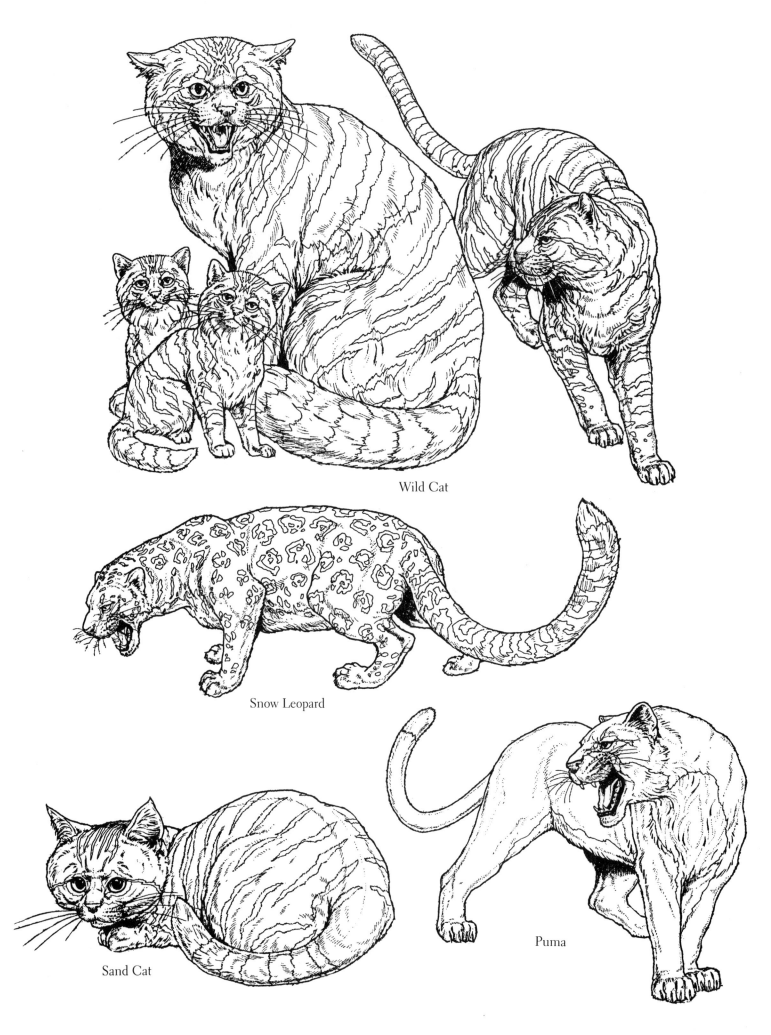

Wild Cat

Snow Leopard

Sand Cat

Puma

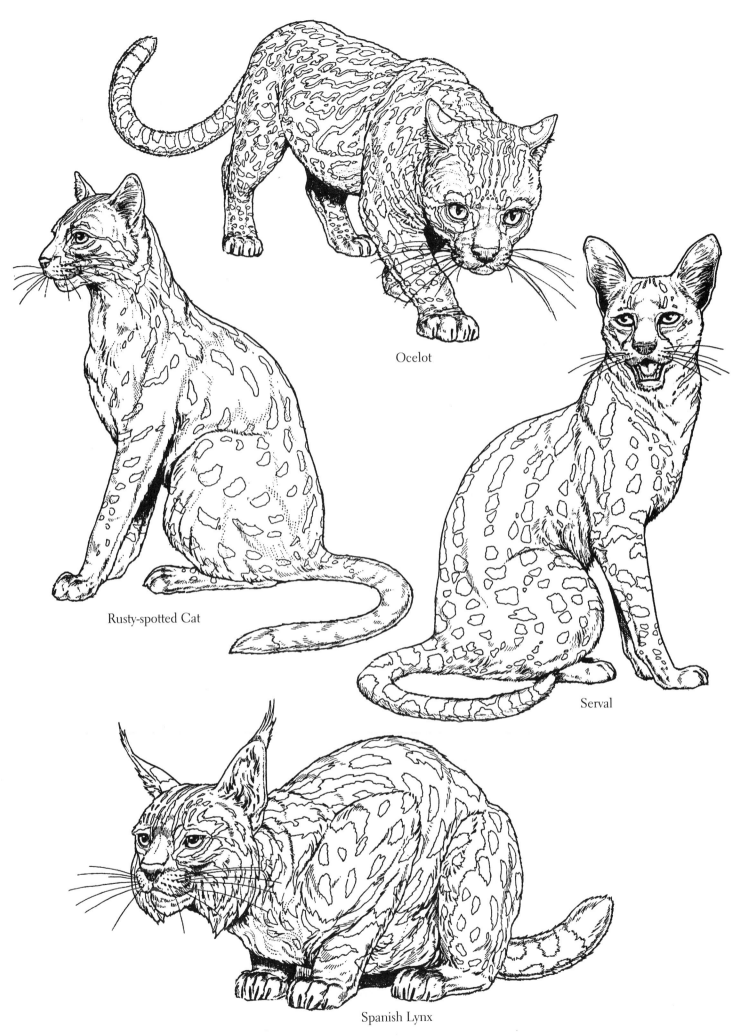

Ocelot

Rusty-spotted Cat

Serval

Spanish Lynx

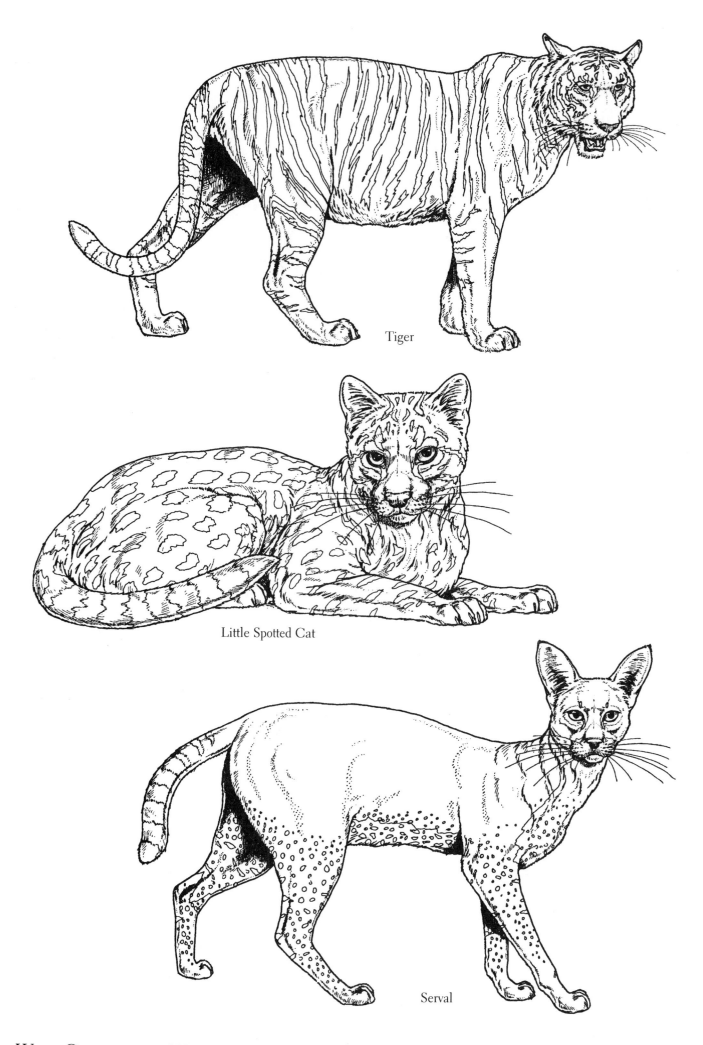

Tiger

Little Spotted Cat

Serval

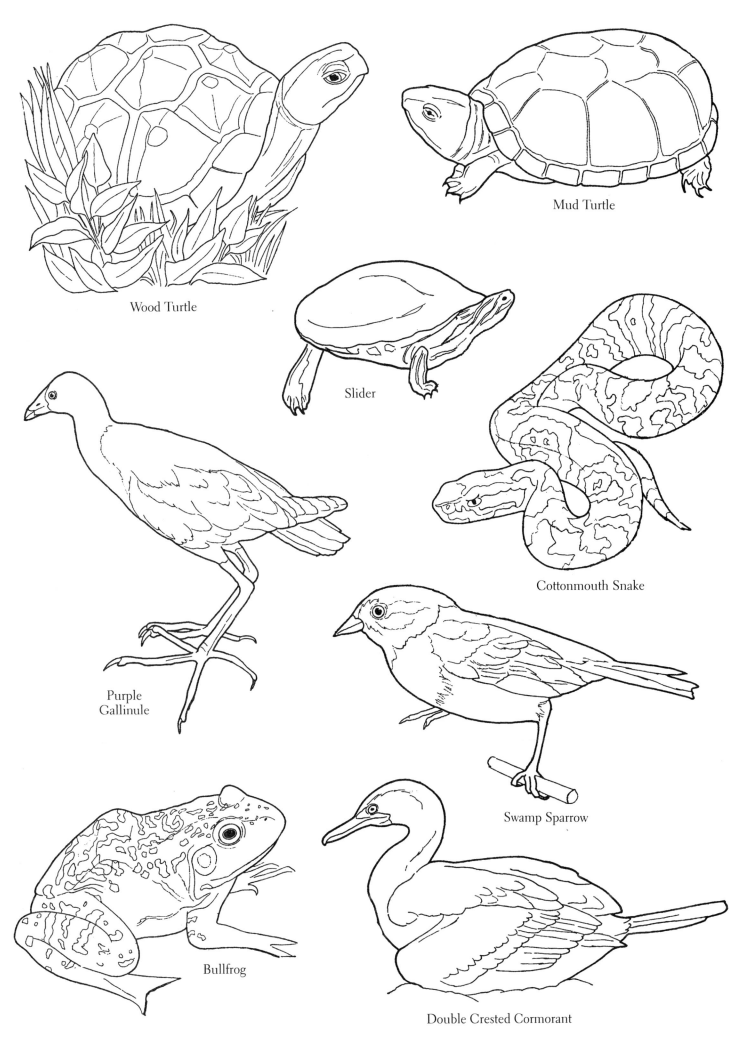

Wood Turtle

Mud Turtle

Slider

Cottonmouth Snake

Purple
Gallinule

Swamp Sparrow

Bullfrog

Double Crested Cormorant

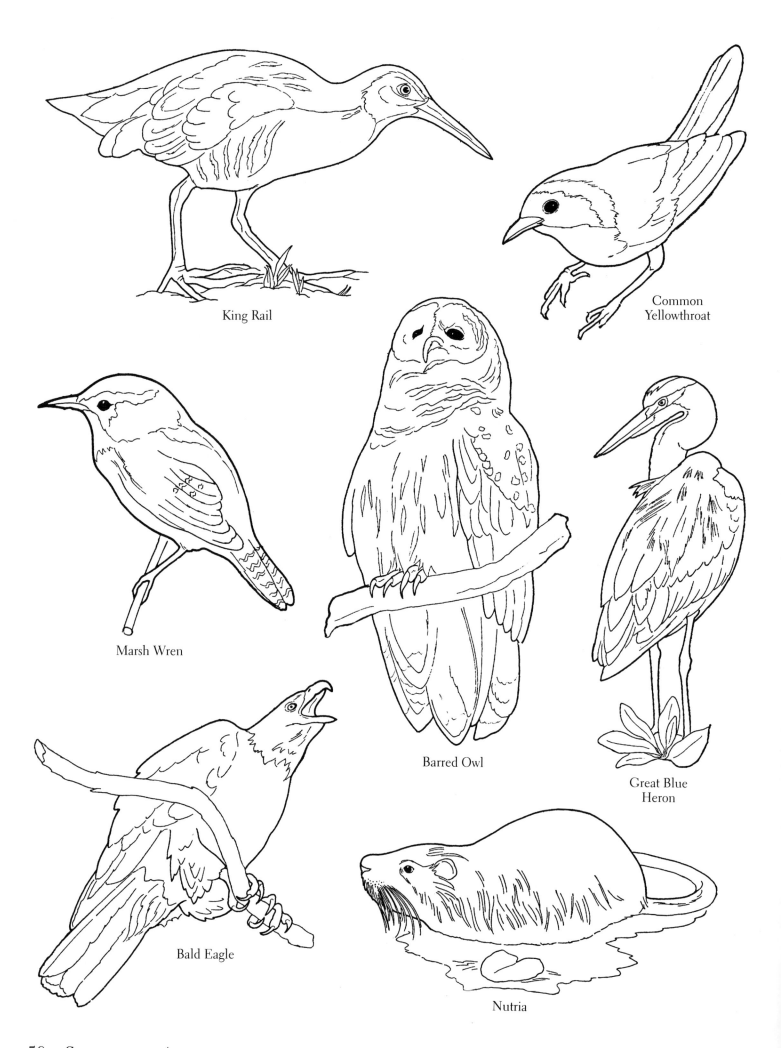

King Rail

Common
Yellowthroat

Marsh Wren

Barred Owl

Great Blue
Heron

Bald Eagle

Nutria

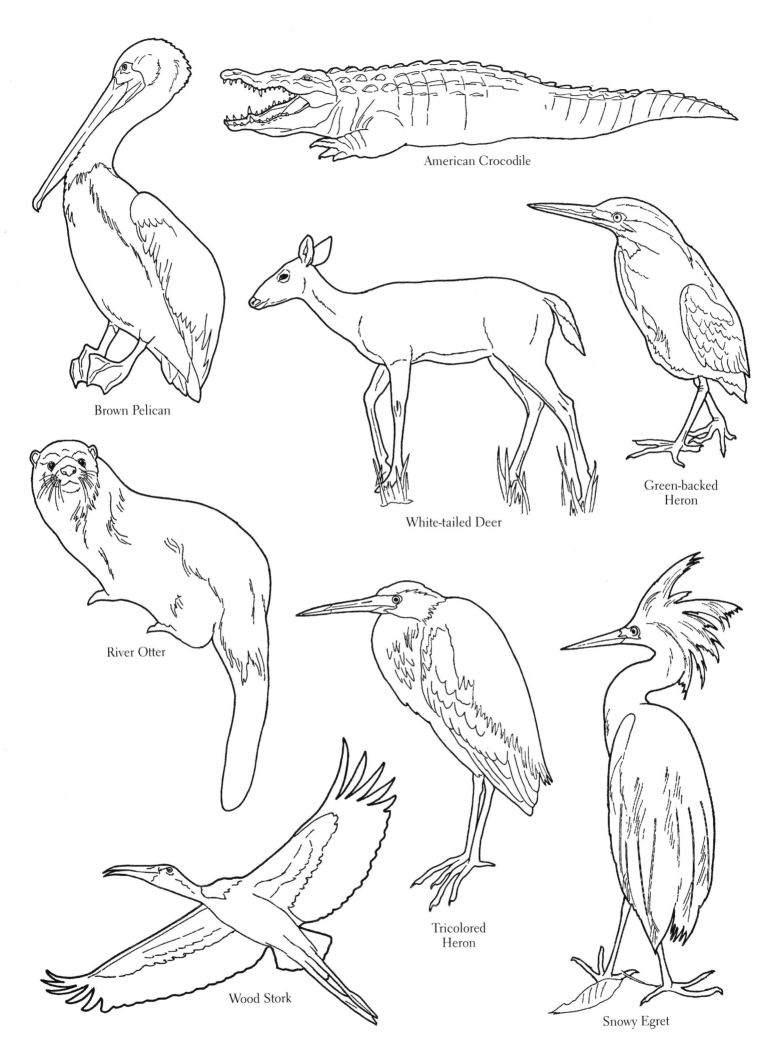

American Crocodile

Brown Pelican

White-tailed Deer

Green-backed
Heron

River Otter

Tricolored
Heron

Wood Stork

Snowy Egret

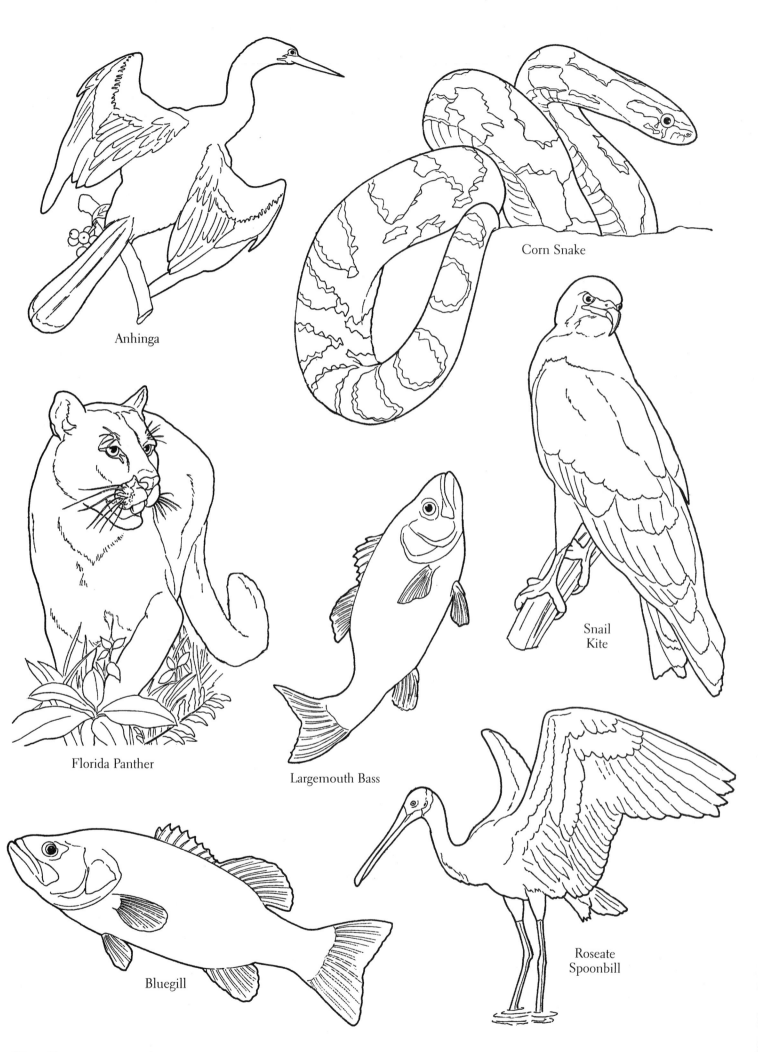

Anhinga

Corn Snake

Florida Panther

Largemouth Bass

Snail
Kite

Bluegill

Roseate
Spoonbill

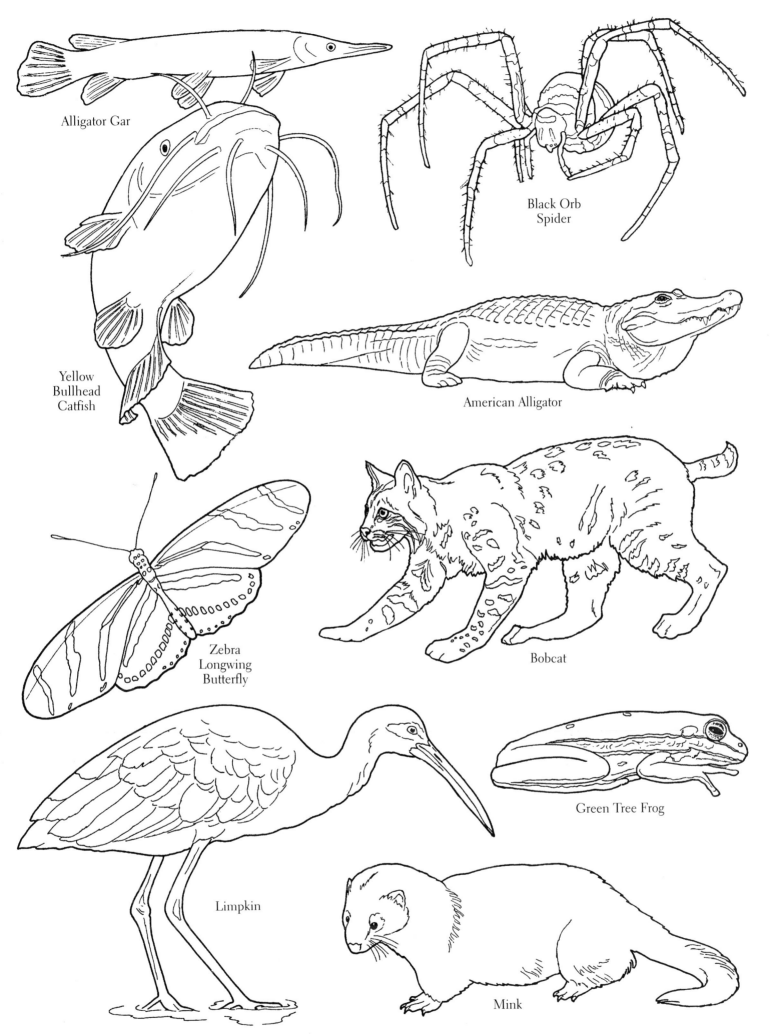

Alligator Gar

Black Orb
Spider

Yellow
Bullhead
Catfish

American Alligator

Zebra
Longwing
Butterfly

Bobcat

Green Tree Frog

Limpkin

Mink

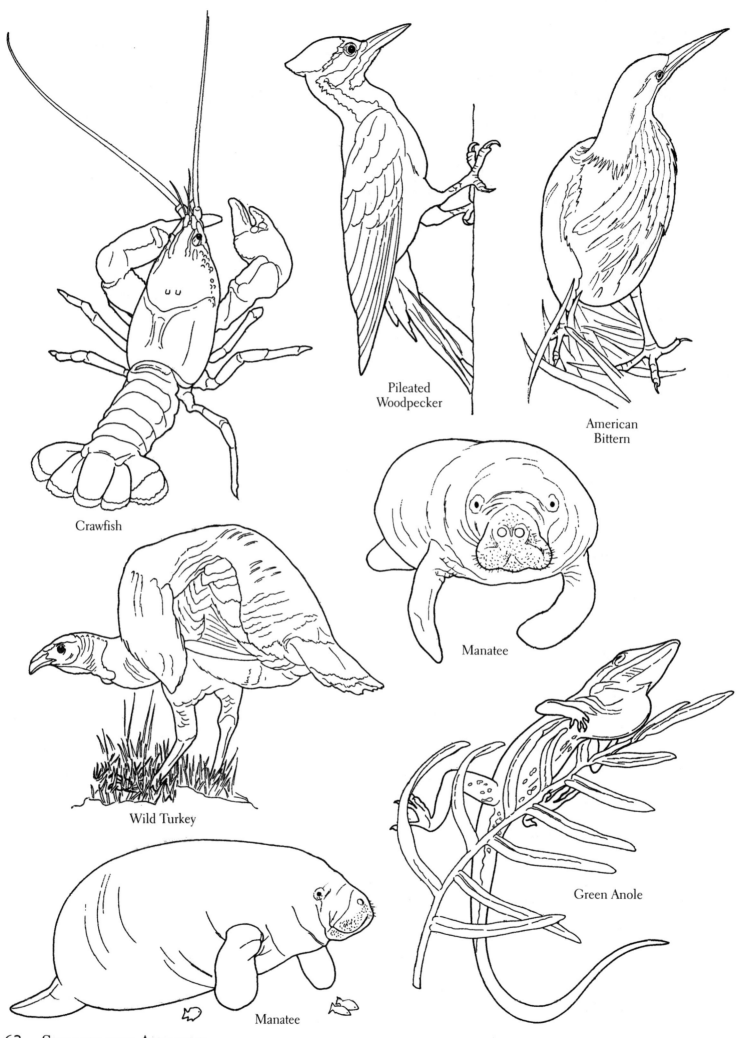

Crawfish

Pileated
Woodpecker

American
Bittern

Manatee

Wild Turkey

Green Anole

Manatee

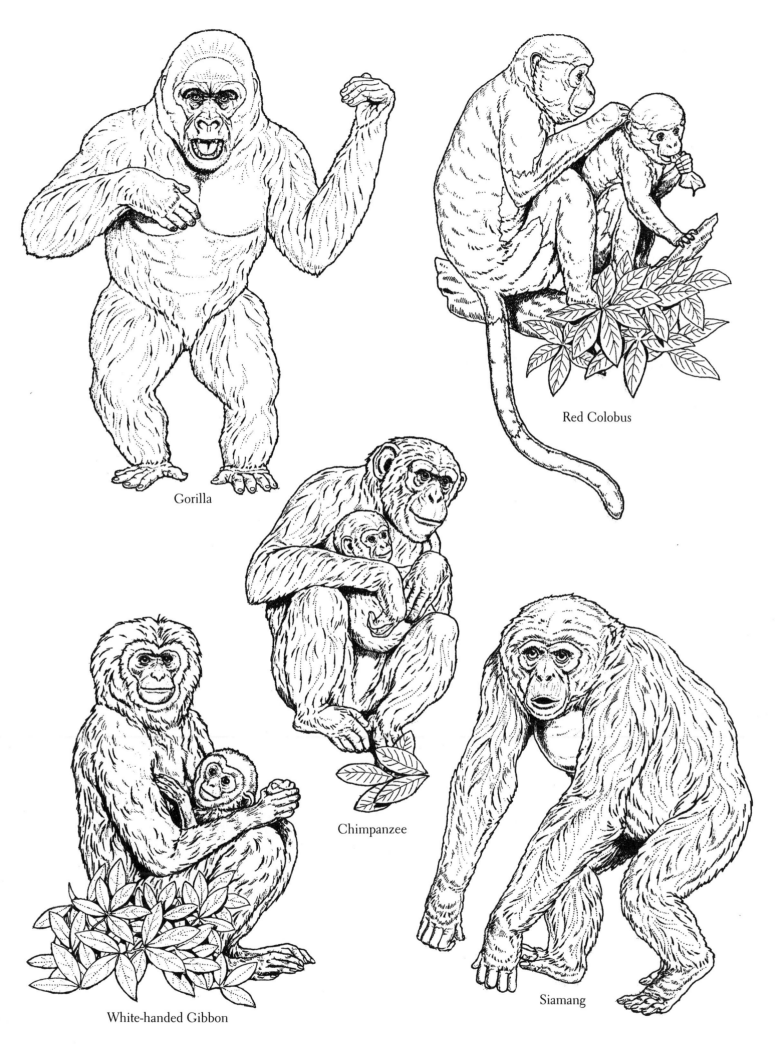

Gorilla

Red Colobus

Chimpanzee

White-handed Gibbon

Siamang

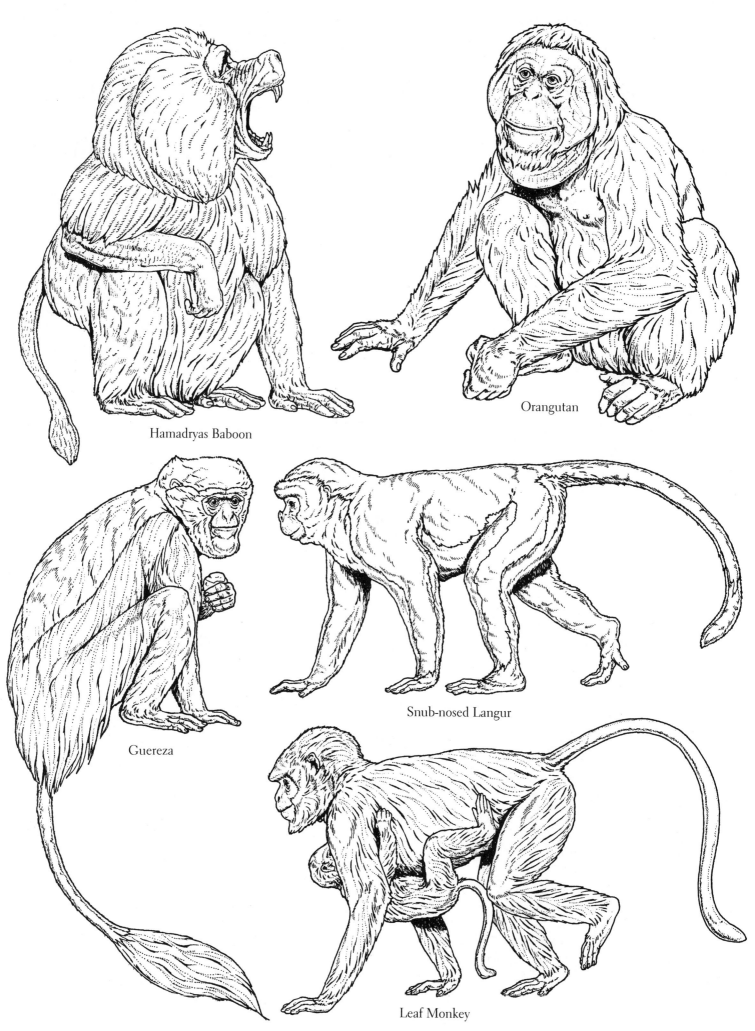

Hamadryas Baboon

Orangutan

Guereza

Snub-nosed Langur

Leaf Monkey

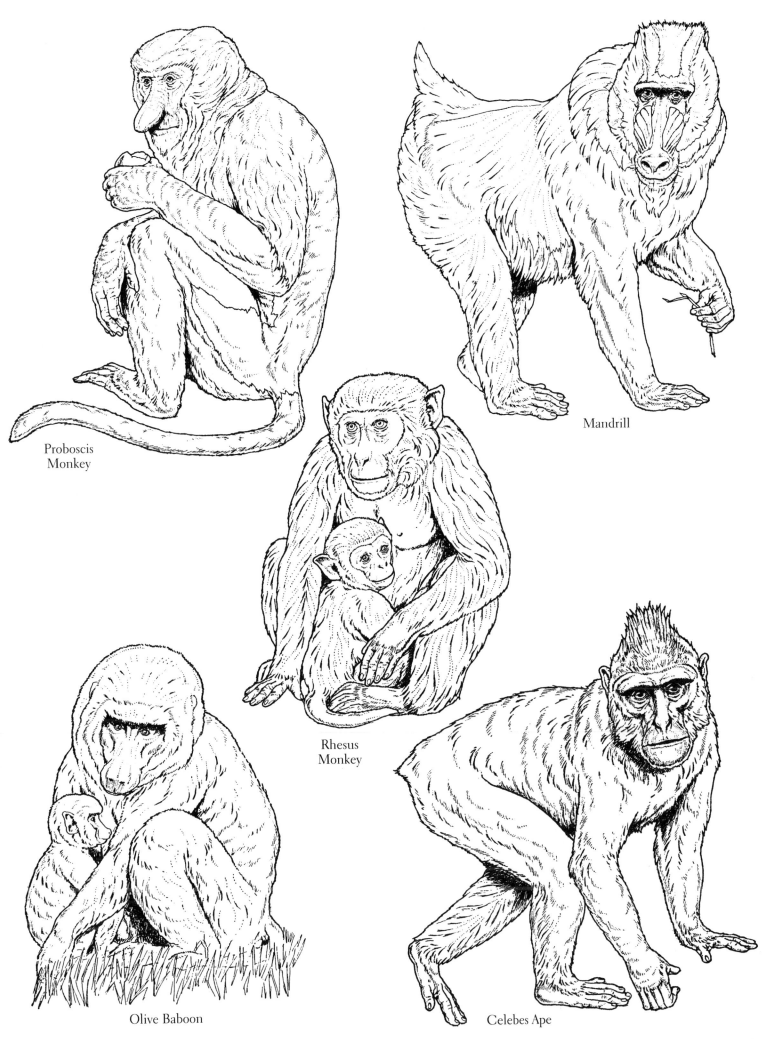

Proboscis
Monkey

Mandrill

Rhesus
Monkey

Olive Baboon

Celebes Ape

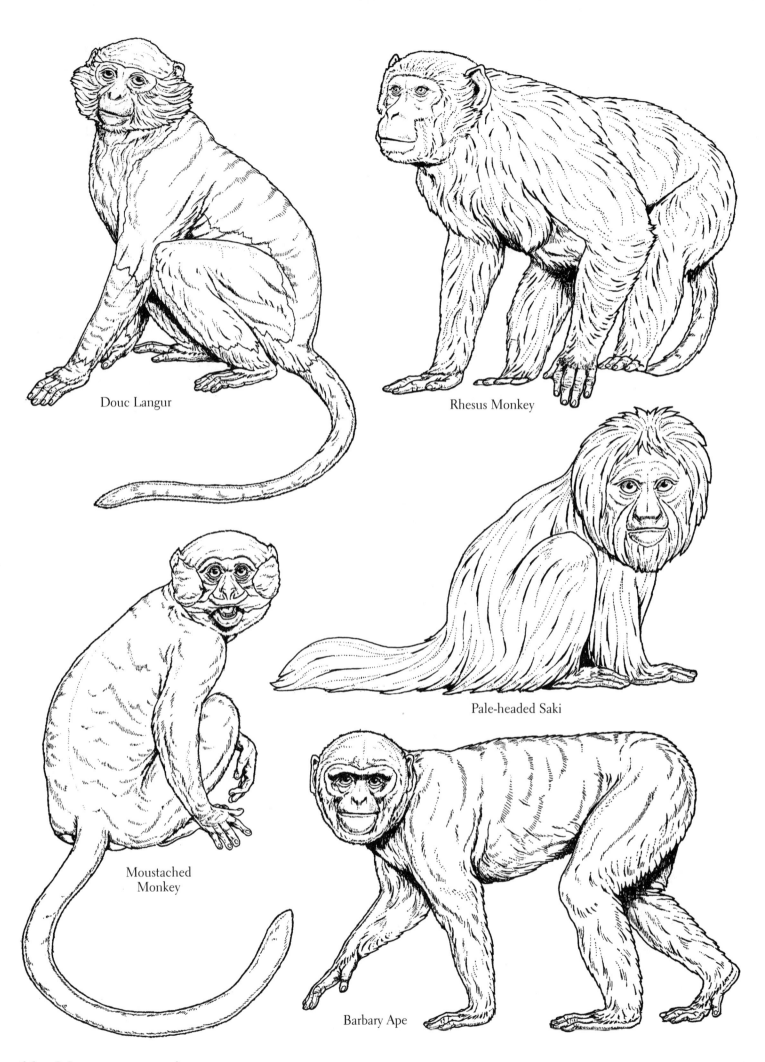

Douc Langur

Rhesus Monkey

Pale-headed Saki

Moustached
Monkey

Barbary Ape

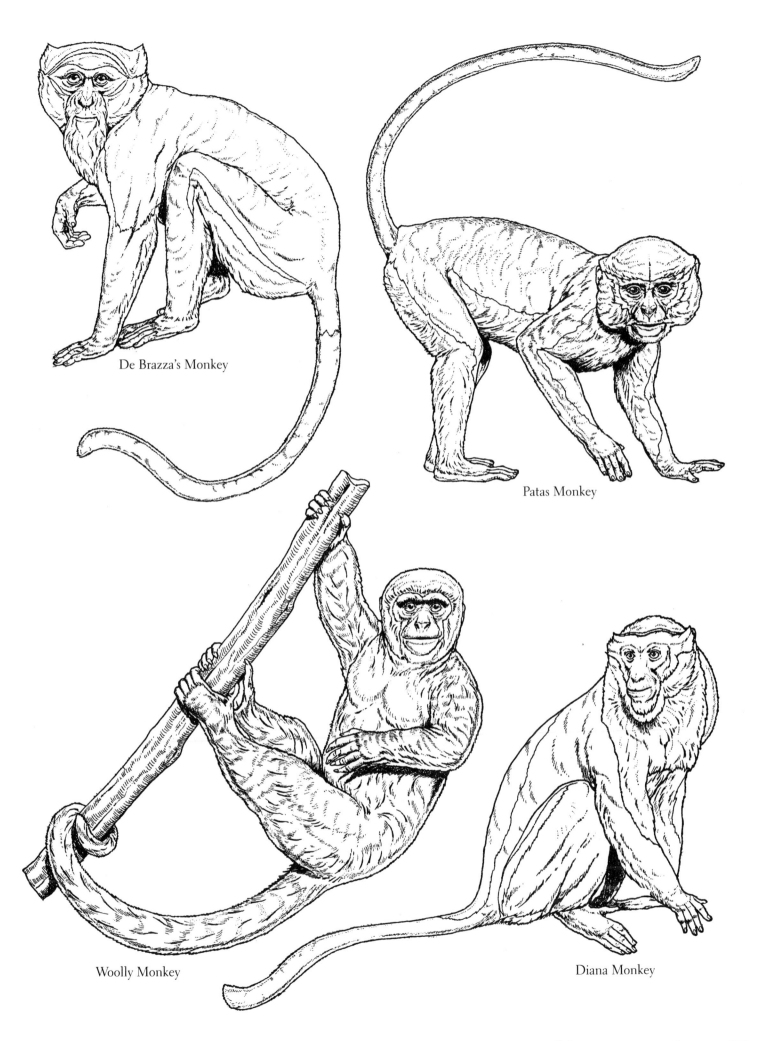

De Brazza's Monkey

Patas Monkey

Woolly Monkey

Diana Monkey

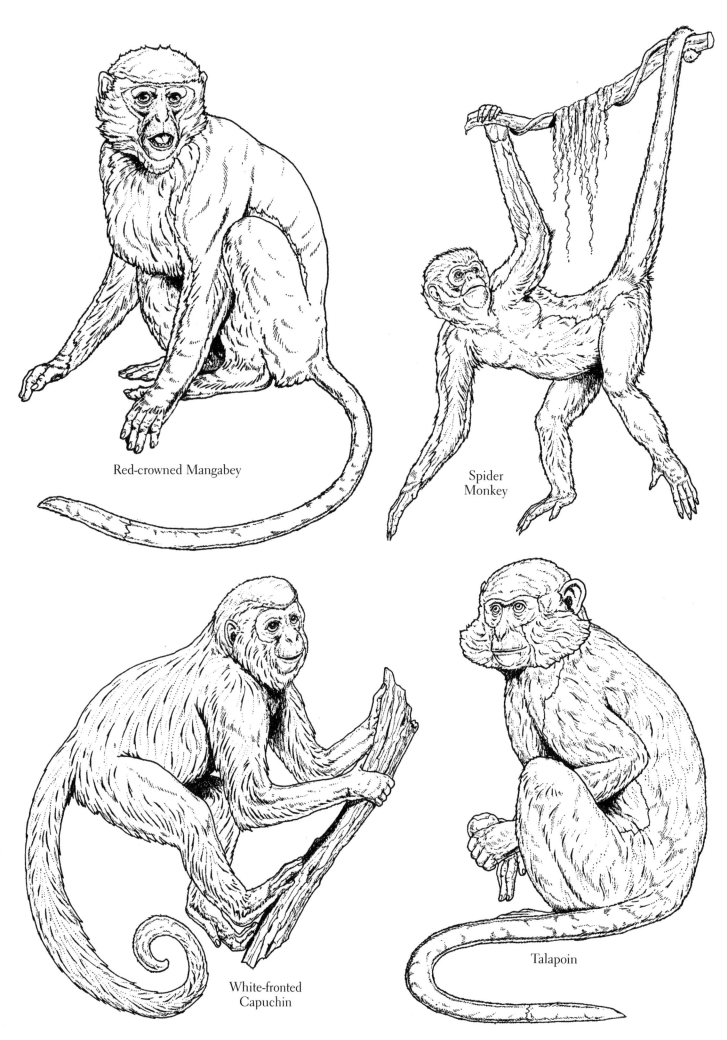

Red-crowned Mangabey

Spider
Monkey

White-fronted
Capuchin

Talapoin

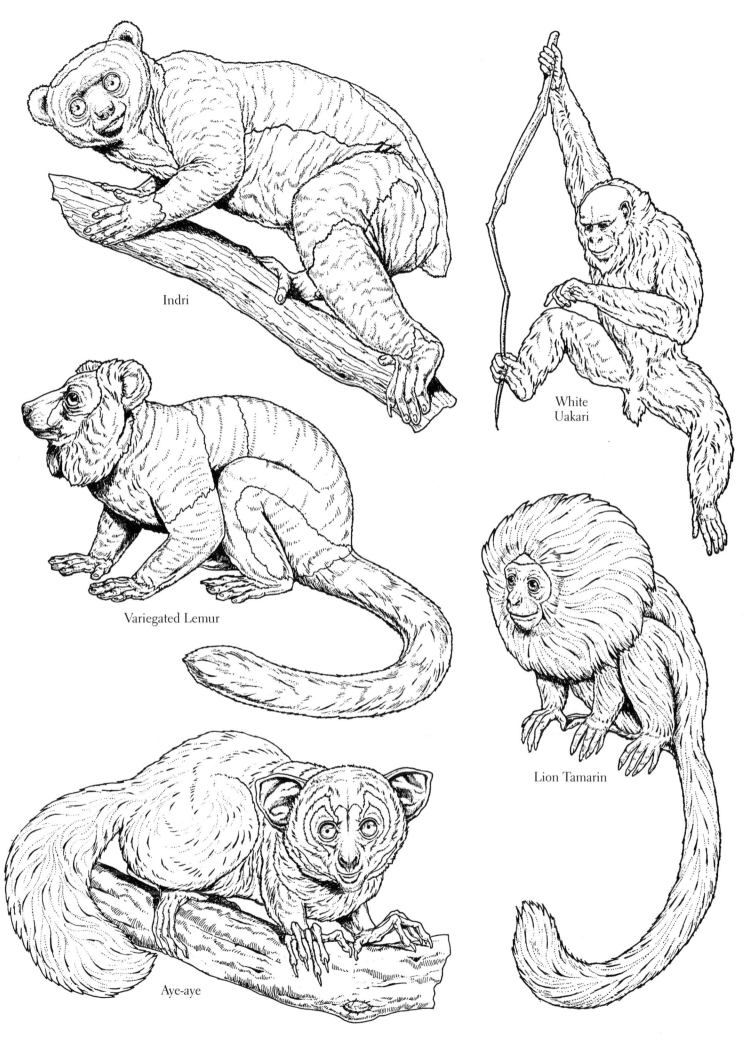

Indri

White
Uakari

Variegated Lemur

Lion Tamarin

Aye-aye

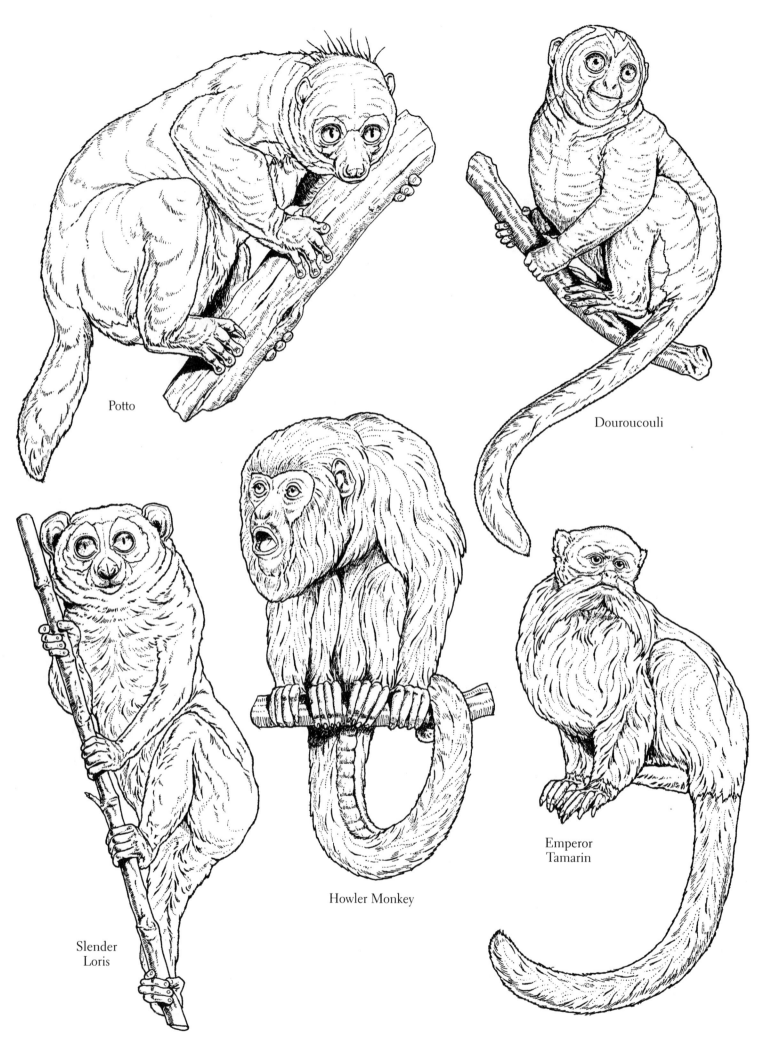

Potto

Douroucouli

Slender
Loris

Howler Monkey

Emperor
Tamarin

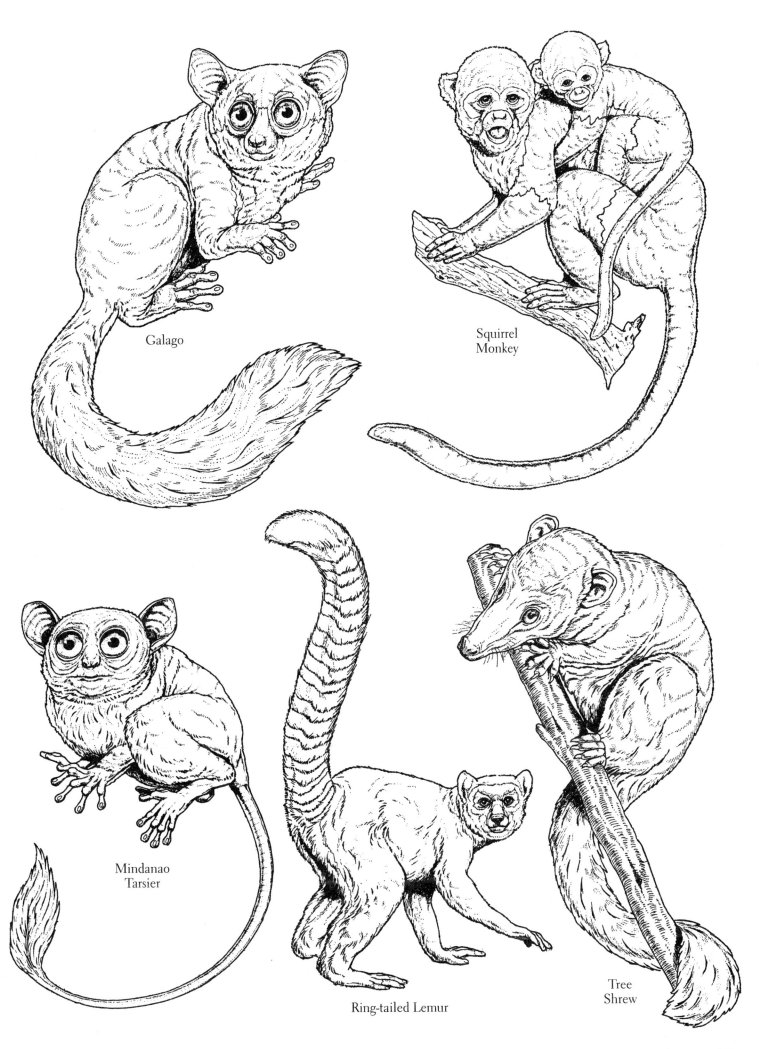

Galago

Squirrel
Monkey

Mindanao
Tarsier

Ring-tailed Lemur

Tree
Shrew

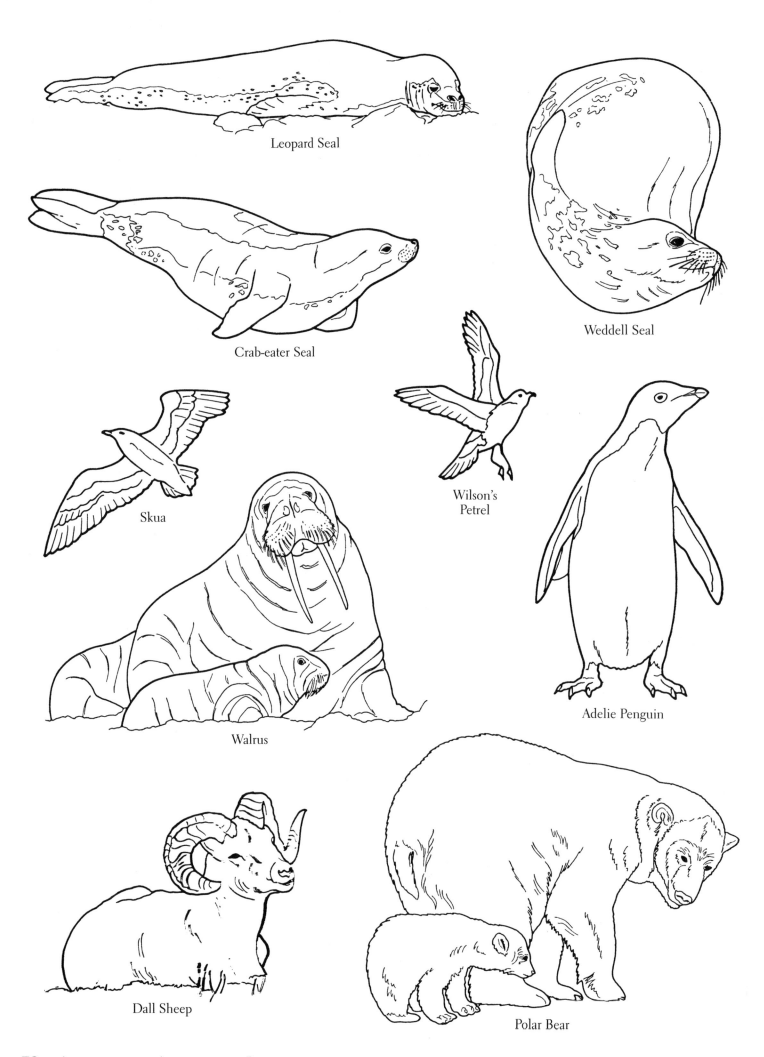

Leopard Seal

Weddell Seal

Crab-eater Seal

Wilson's
Petrel

Skua

Walrus

Adelie Penguin

Dall Sheep

Polar Bear

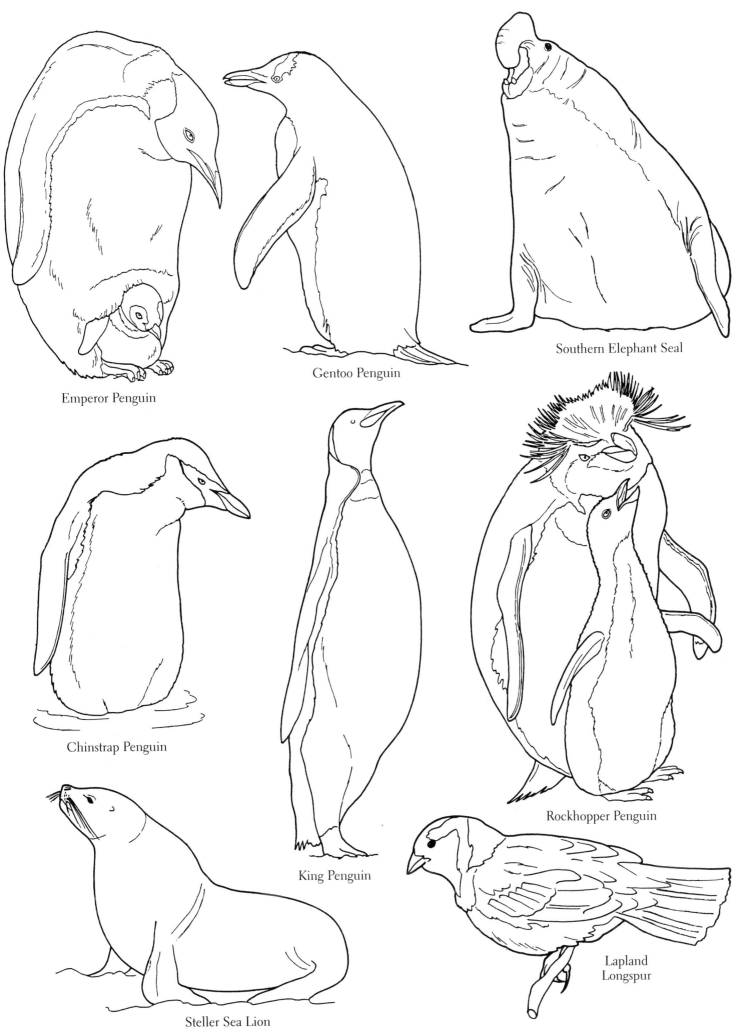

Emperor Penguin

Gentoo Penguin

Southern Elephant Seal

Chinstrap Penguin

King Penguin

Rockhopper Penguin

Steller Sea Lion

Lapland
Longspur

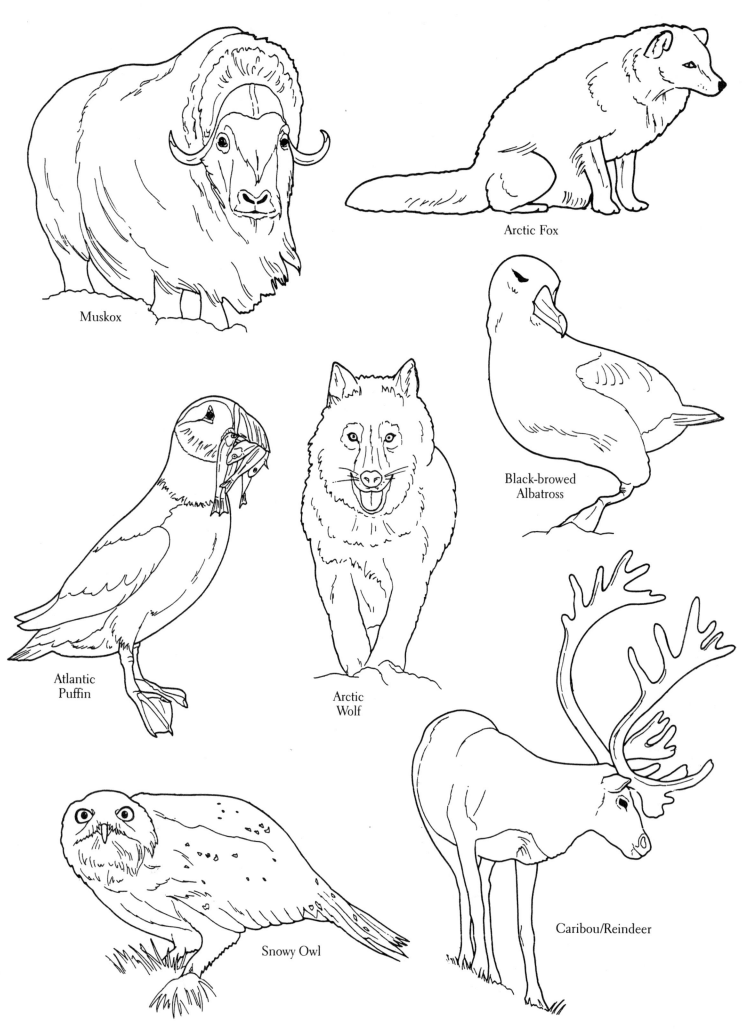

Muskox

Arctic Fox

Black-browed
Albatross

Atlantic
Puffin

Arctic
Wolf

Caribou/Reindeer

Snowy Owl

Arctic Hare

Narwhal

Minke
Whale

Gyr
Falcon

Killer
Whale

Arctic Tern

Beluga Whale

Willow Ptarmigan

Baird's Beaked Whale

Pygmy Right Whale

Harp Seal

Sei Whale

Bowhead Whale

Arctic Butterfly

Ringed Seal

Lions Mane Jellyfish

Sea Snail

Parasitic Jaeger

King Eider

Emperor Goose

Black Guillemot

North American
Mountain Goat

Grizzly Bear

American Bison

Paca

Giant Otter

American Alligator

Sulfur-breasted
Toucan

American Badger

Bighorn Sheep

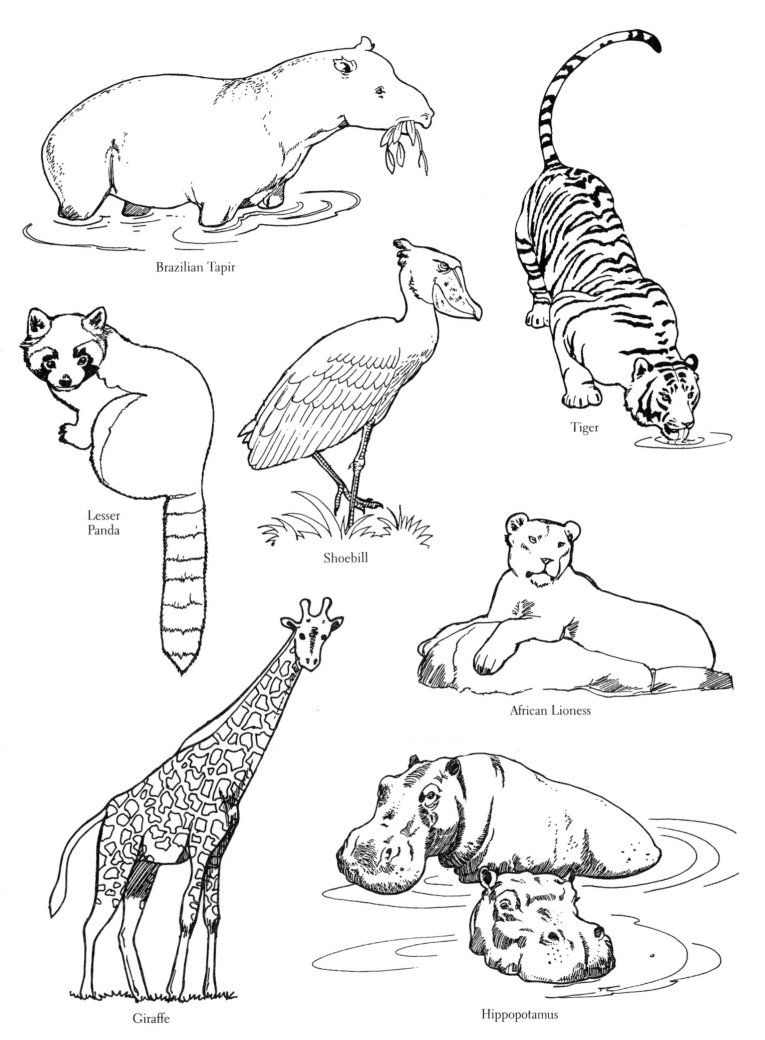

Brazilian Tapir

Tiger

Lesser
Panda

Shoebill

African Lioness

Giraffe

Hippopotamus

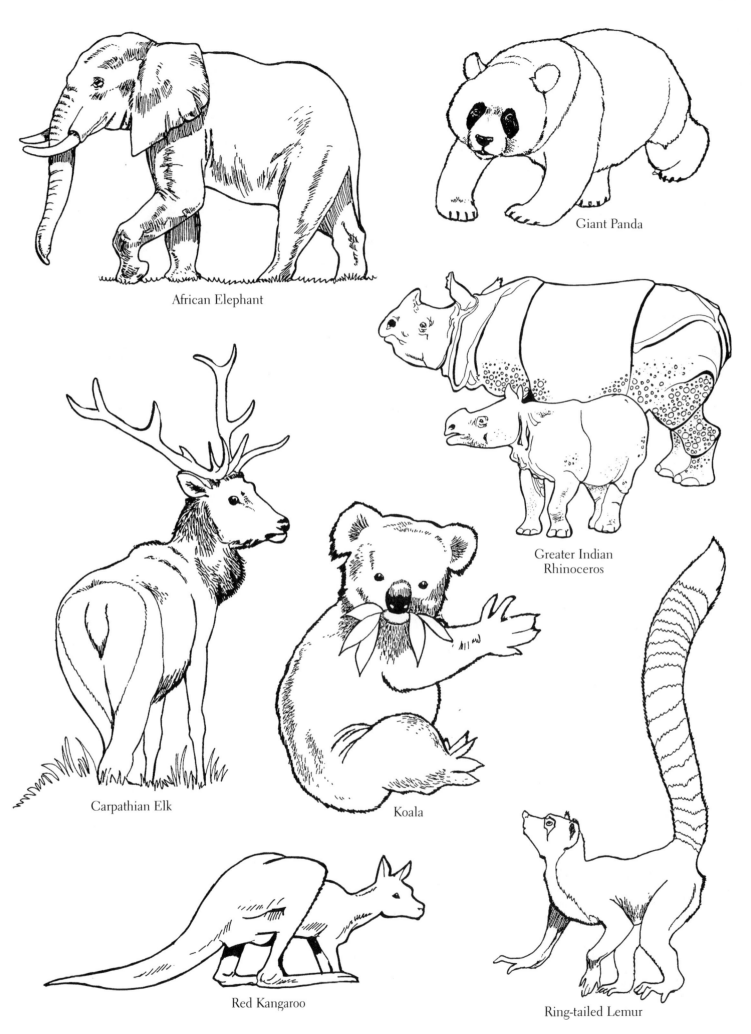

Giant Panda

African Elephant

Greater Indian
Rhinoceros

Carpathian Elk

Koala

Red Kangaroo

Ring-tailed Lemur

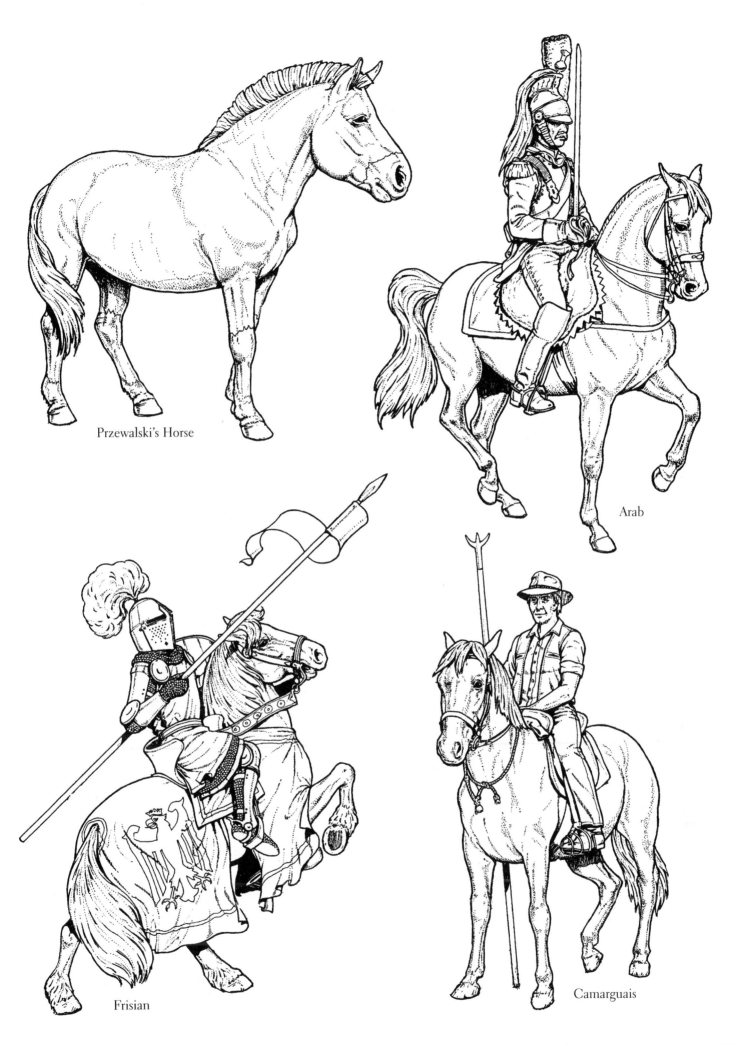

Przewalski's Horse

Arab

Frisian

Camarguais

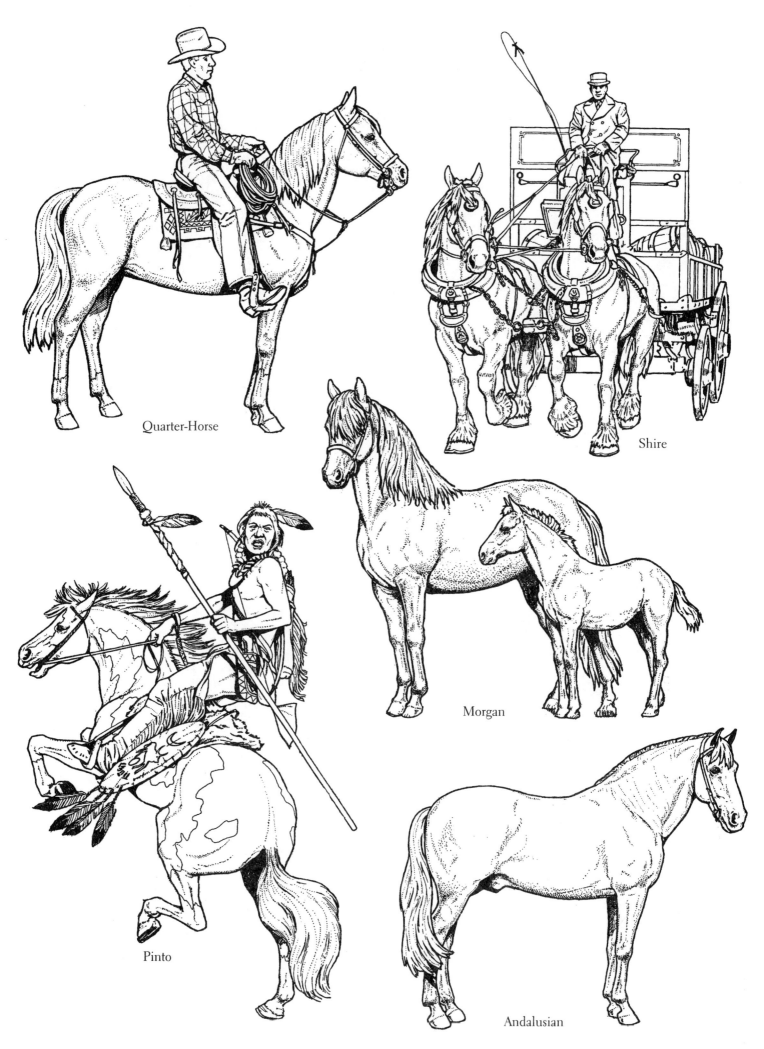

Quarter-Horse

Shire

Morgan

Pinto

Andalusian

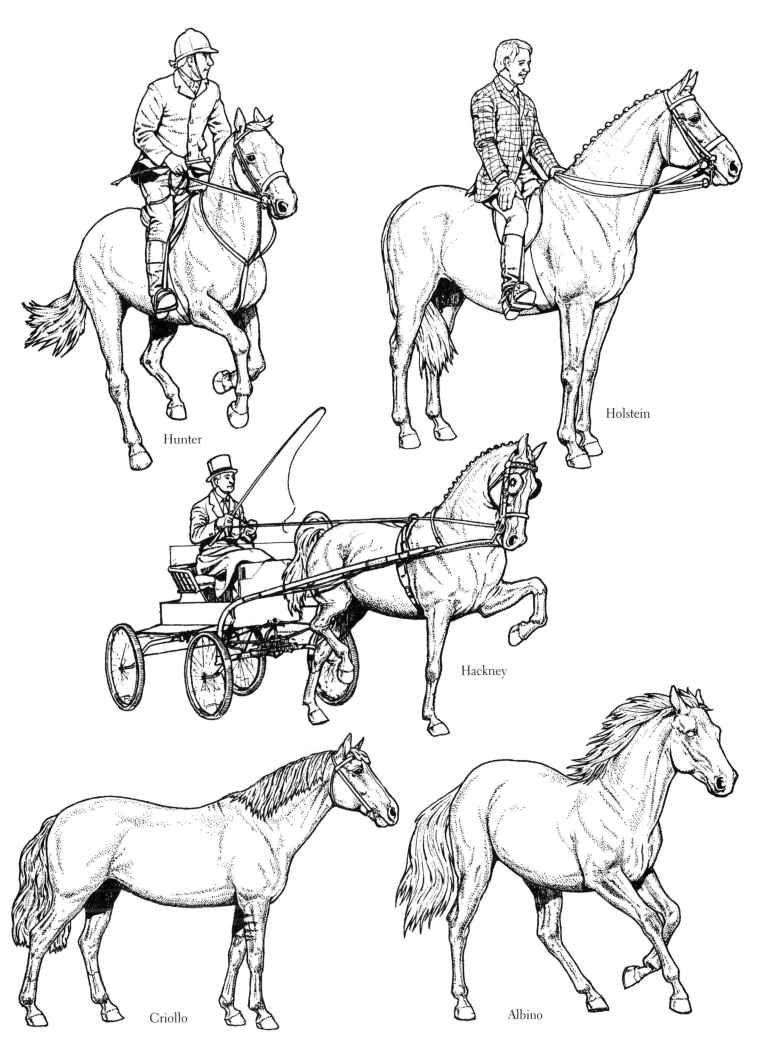

Hunter

Holstein

Hackney

Criollo

Albino

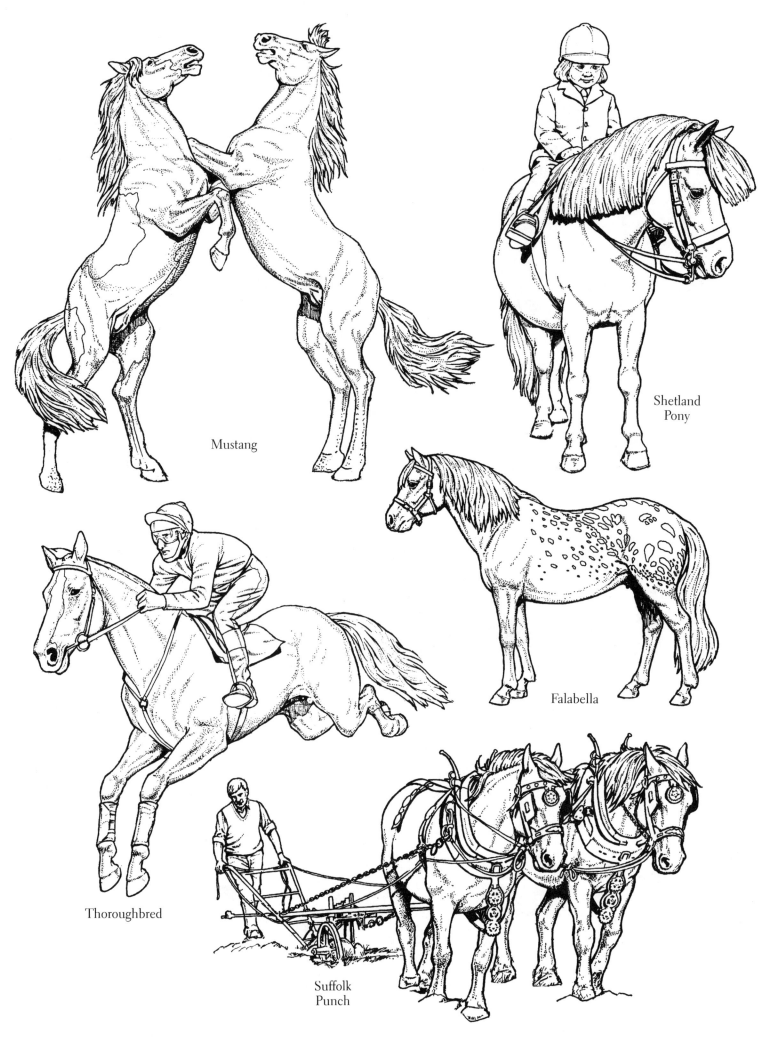

Mustang

Shetland
Pony

Falabella

Thoroughbred

Suffolk
Punch

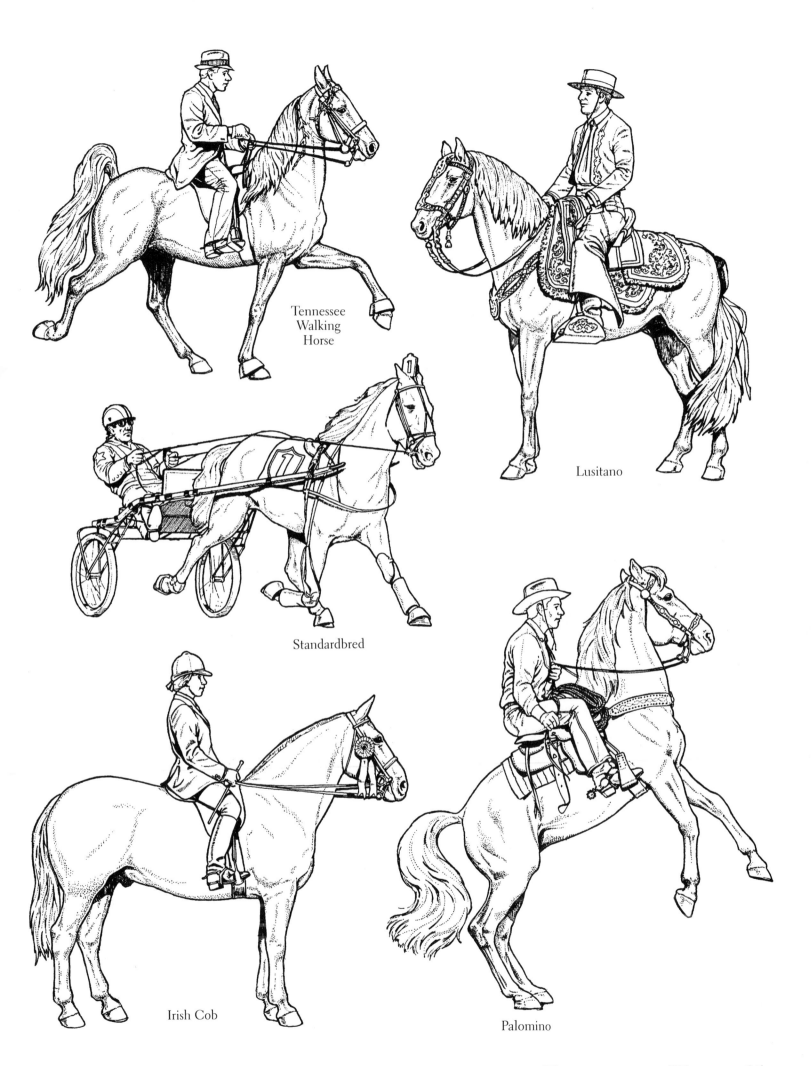

Tennessee
Walking
Horse

Lusitano

Standardbred

Irish Cob

Palomino

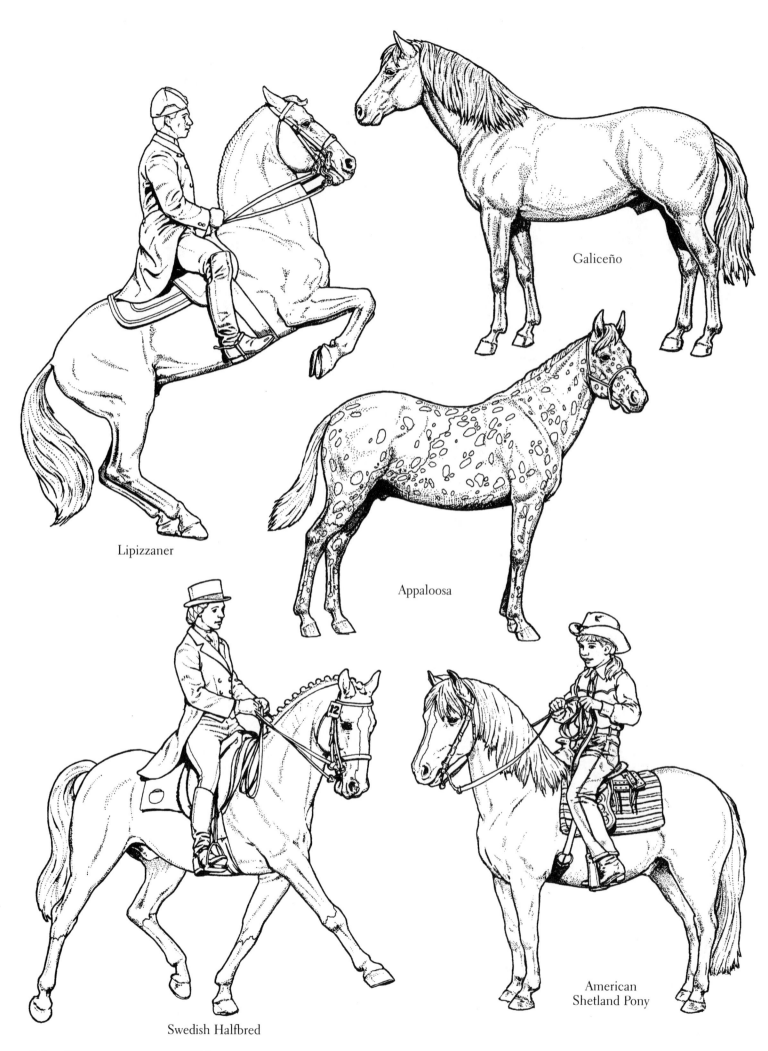

Galiceño

Lipizzaner

Appaloosa

Swedish Halfbred

American
Shetland Pony

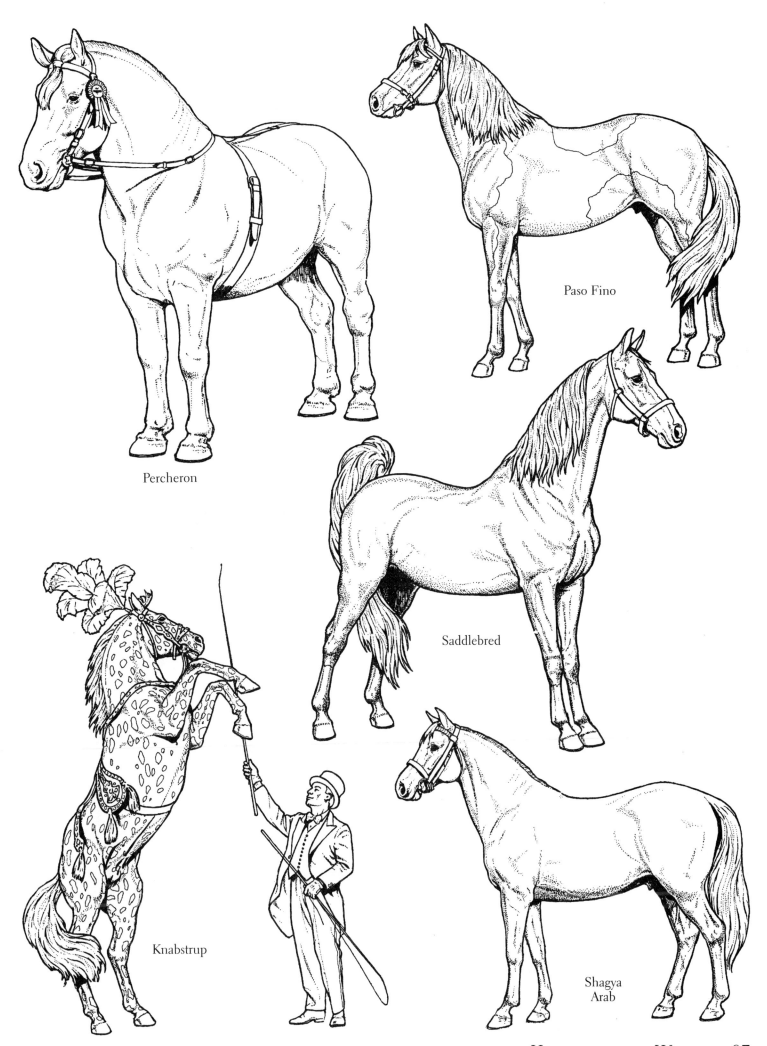

Percheron

Paso Fino

Saddlebred

Knabstrup

Shagya
Arab

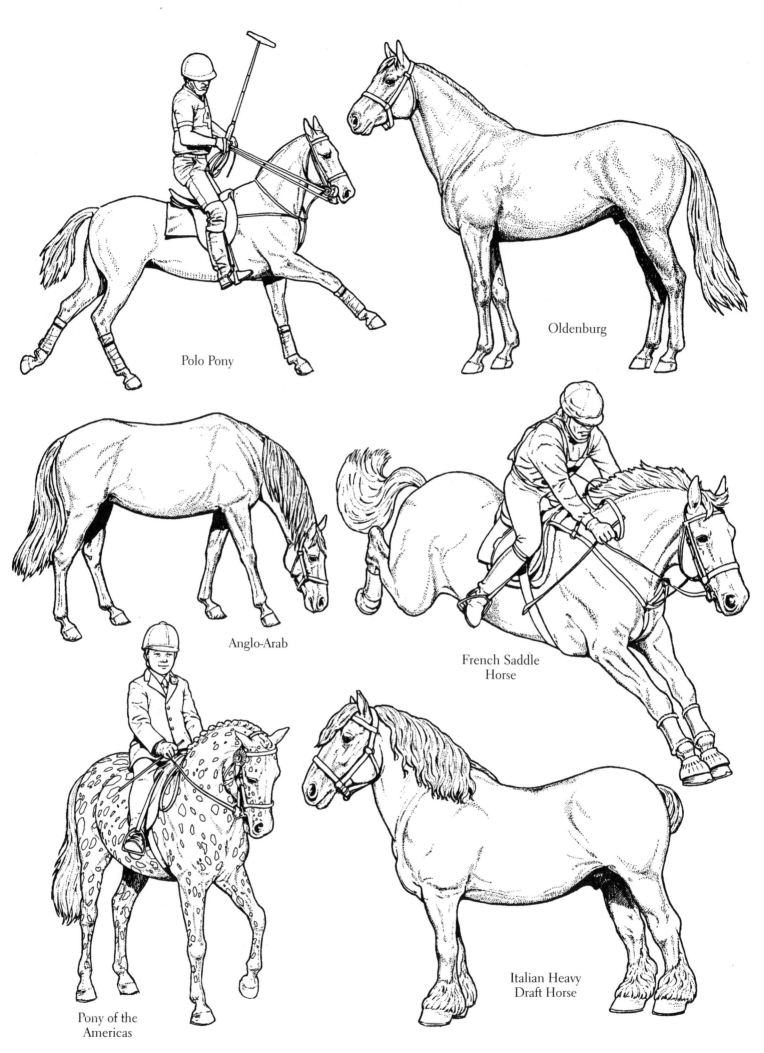

Polo Pony

Oldenburg

Anglo-Arab

French Saddle
Horse

Pony of the
Americas

Italian Heavy
Draft Horse

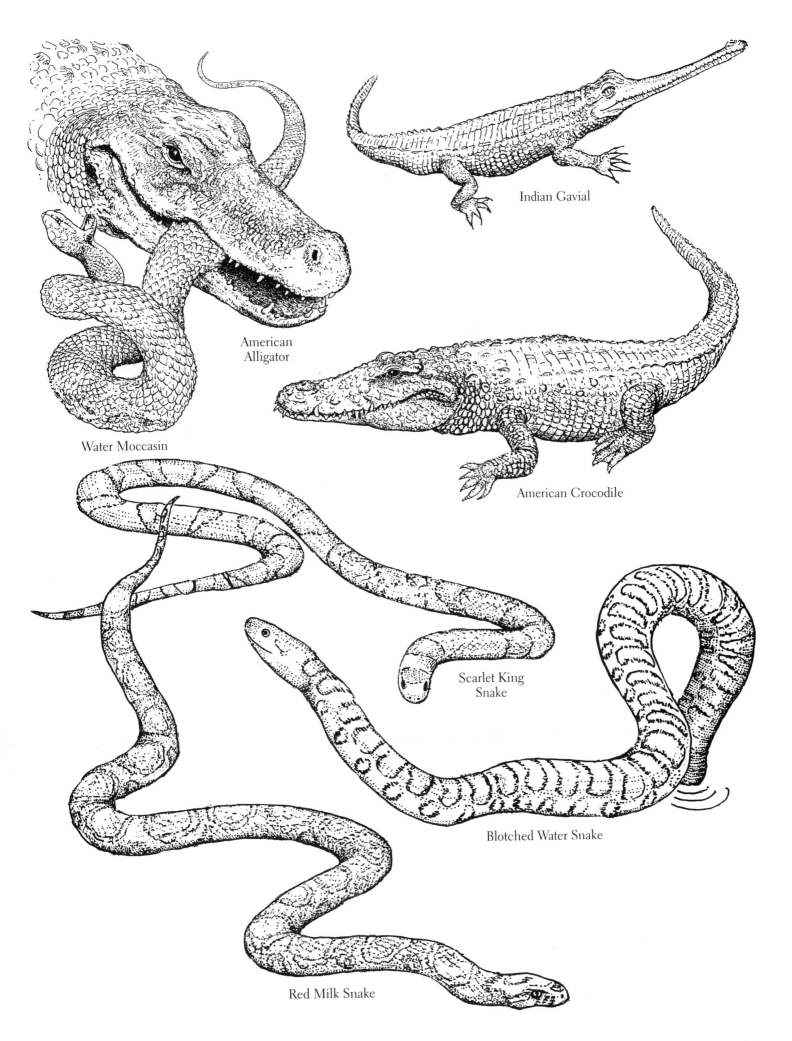

Indian Gavial

American
Alligator

American Crocodile

Water Moccasin

Scarlet King
Snake

Blotched Water Snake

Red Milk Snake

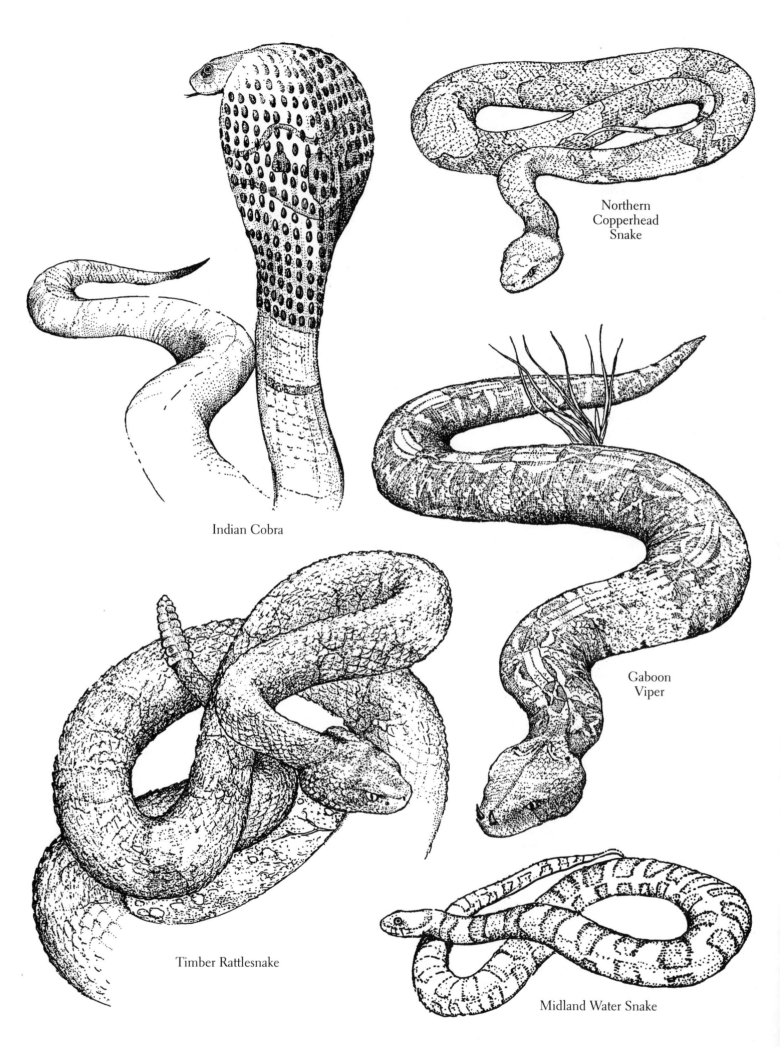

Northern
Copperhead
Snake

Indian Cobra

Gaboon
Viper

Timber Rattlesnake

Midland Water Snake

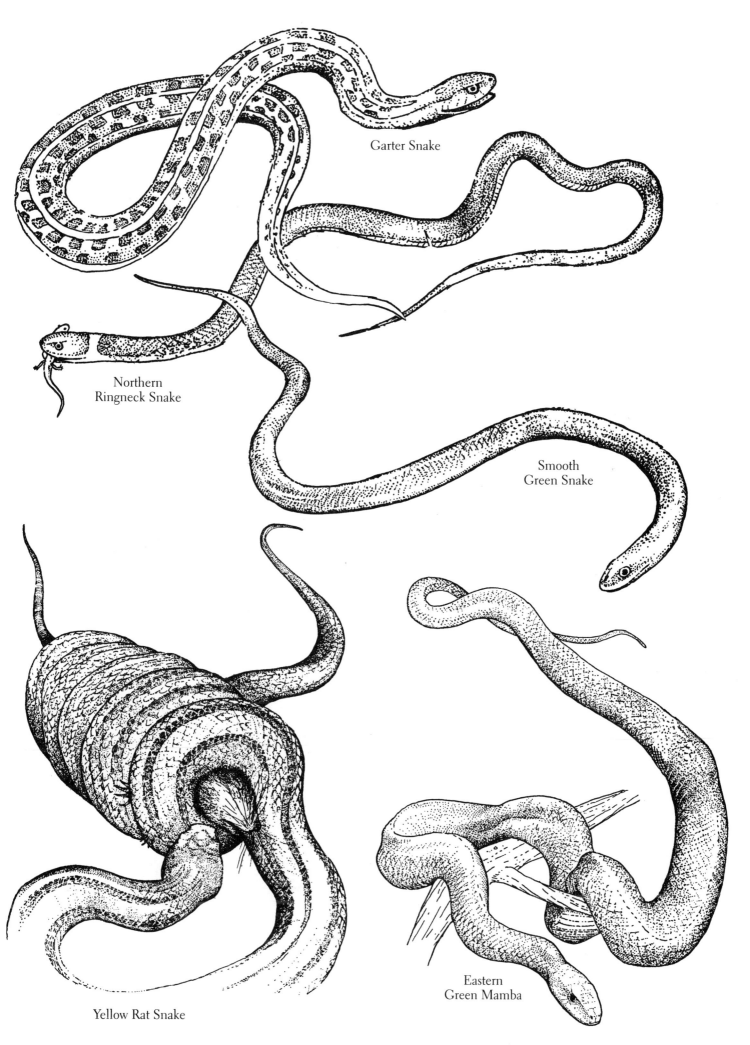

Garter Snake

Northern
Ringneck Snake

Smooth
Green Snake

Yellow Rat Snake

Eastern
Green Mamba

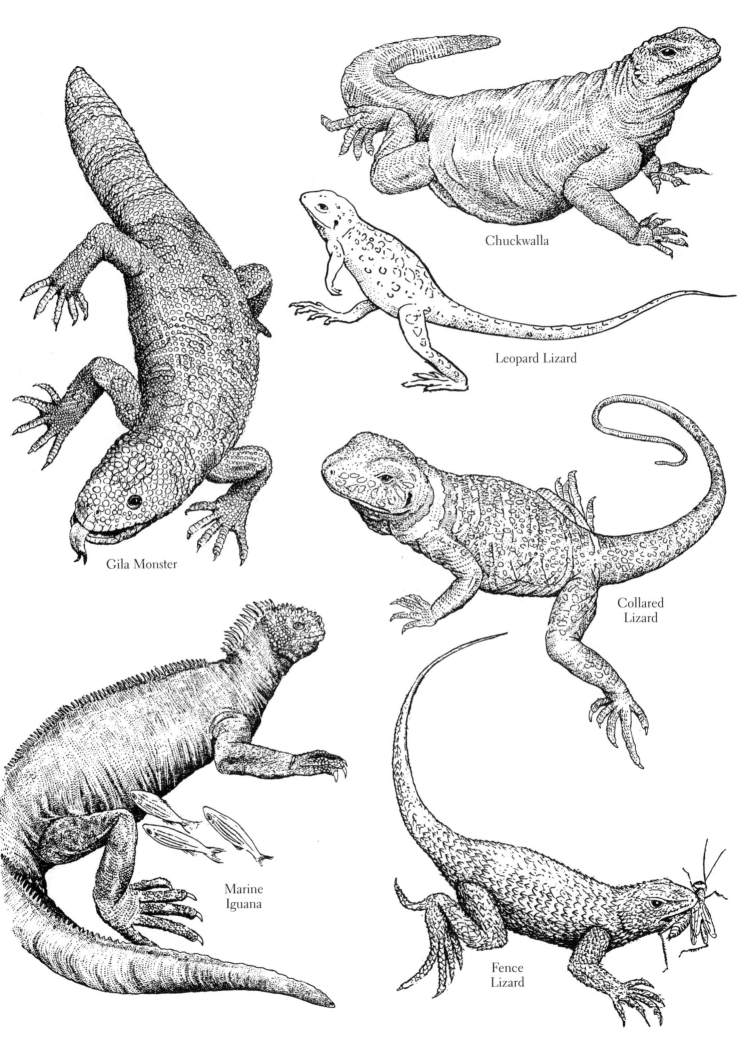

Chuckwalla

Leopard Lizard

Gila Monster

Collared
Lizard

Marine
Iguana

Fence
Lizard

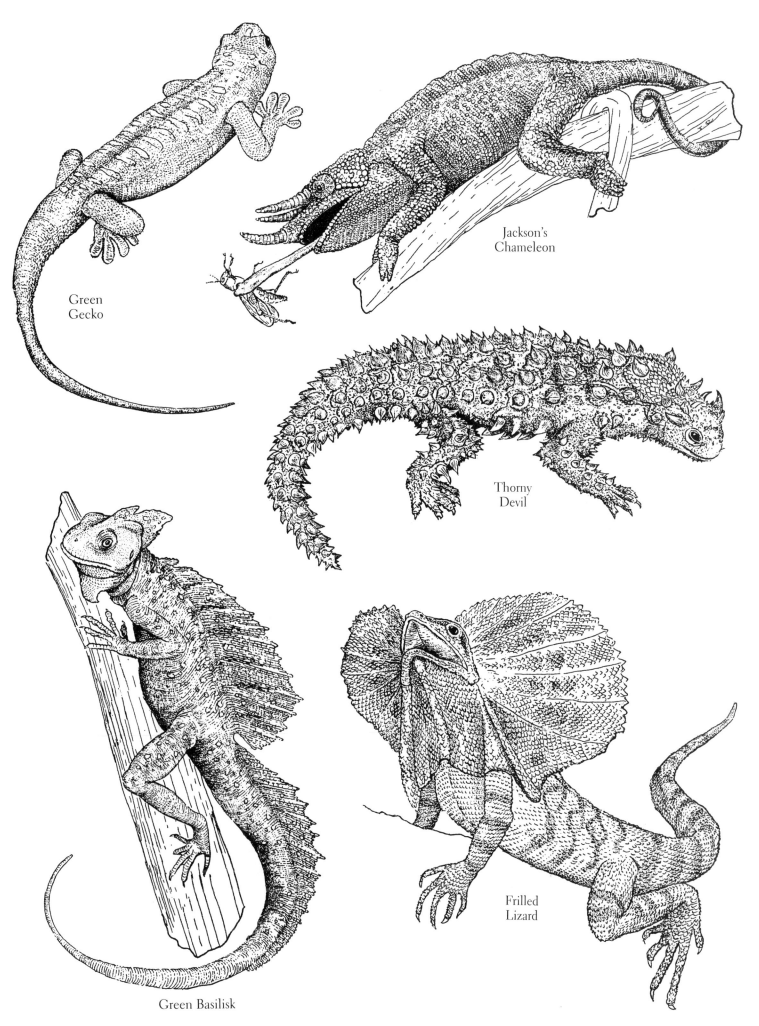

Green
Gecko

Jackson's
Chameleon

Thorny
Devil

Green Basilisk

Frilled
Lizard

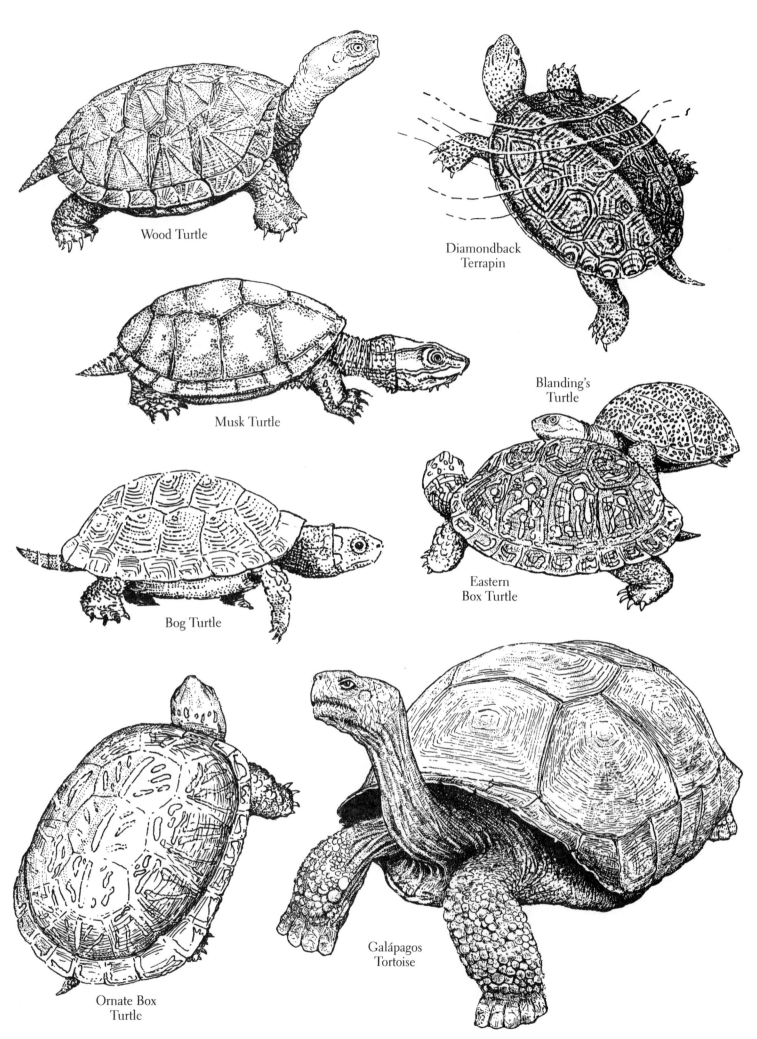

Wood Turtle

Diamondback
Terrapin

Musk Turtle

Blanding's
Turtle

Bog Turtle

Eastern
Box Turtle

Ornate Box
Turtle

Galápagos
Tortoise

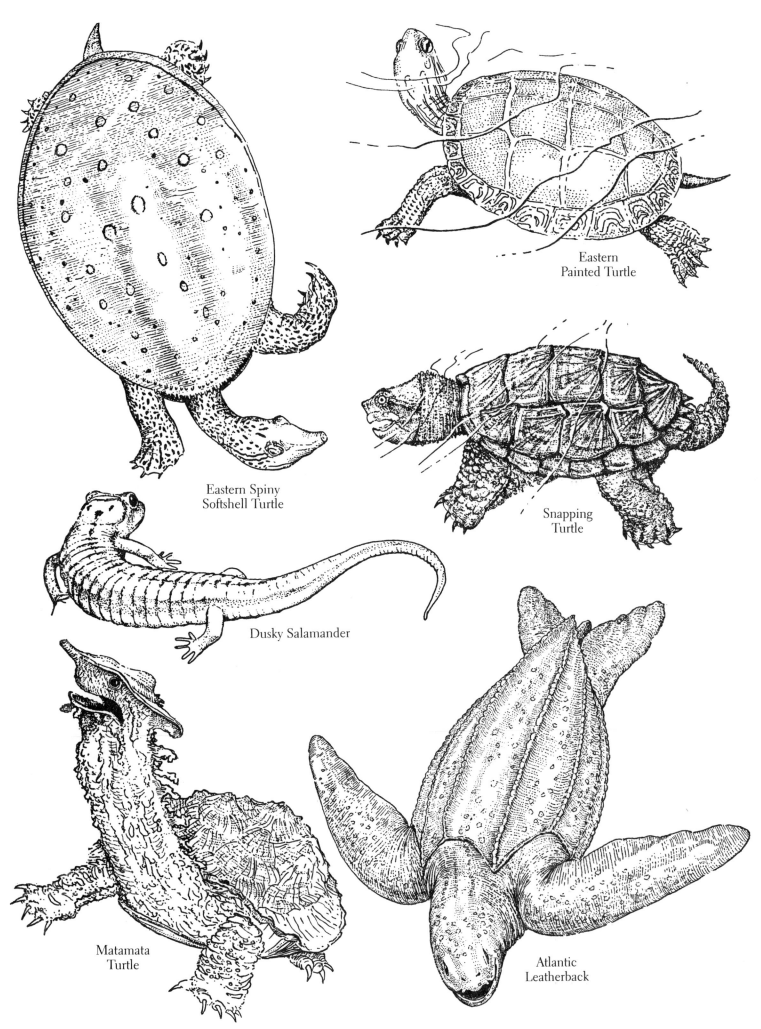

Eastern Painted Turtle

Eastern Spiny
Softshell Turtle

Snapping
Turtle

Dusky Salamander

Matamata
Turtle

Atlantic
Leatherback

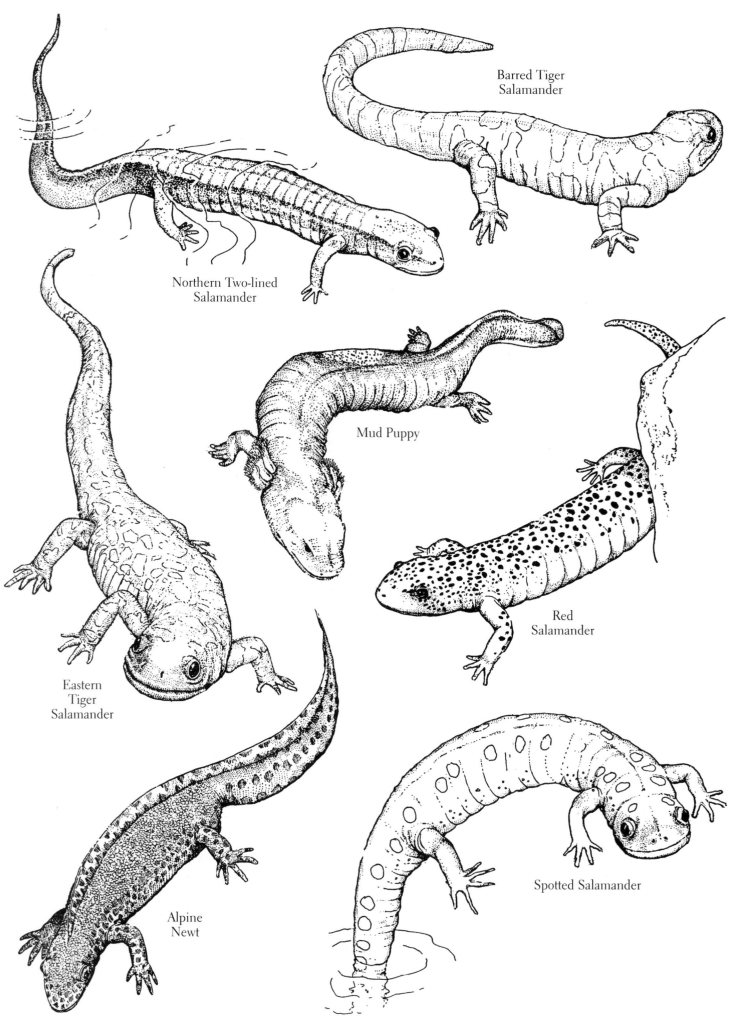

Barred Tiger
Salamander

Northern Two-lined
Salamander

Mud Puppy

Eastern
Tiger
Salamander

Red
Salamander

Alpine
Newt

Spotted Salamander

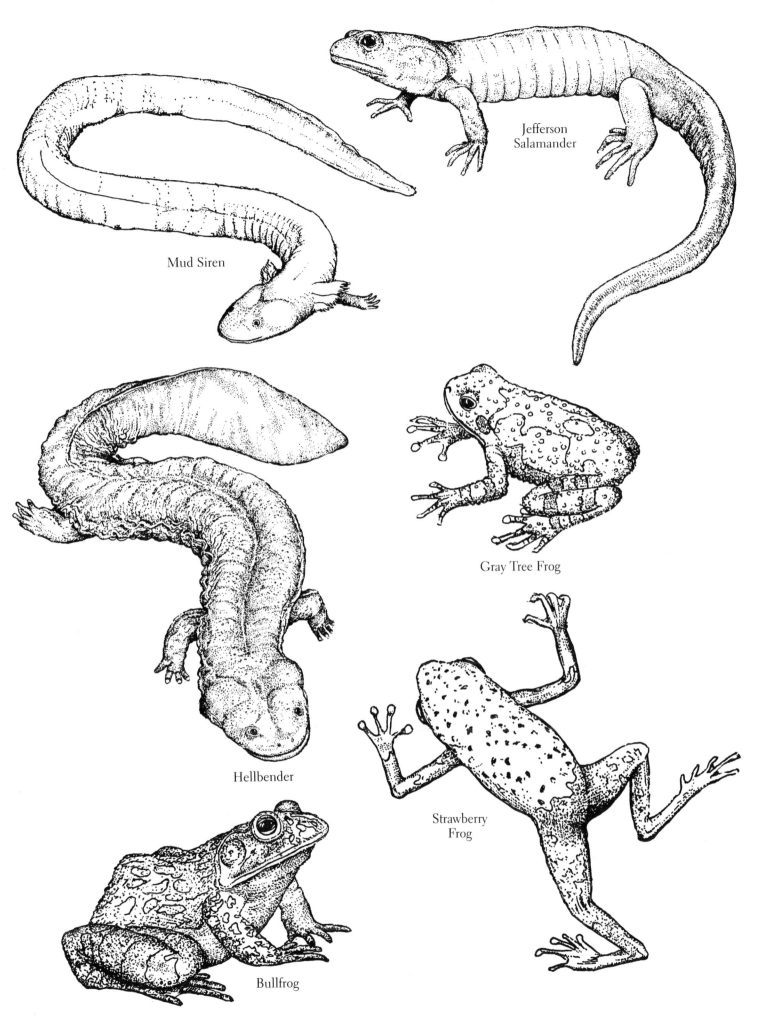

Mud Siren

Jefferson
Salamander

Hellbender

Gray Tree Frog

Strawberry
Frog

Bullfrog

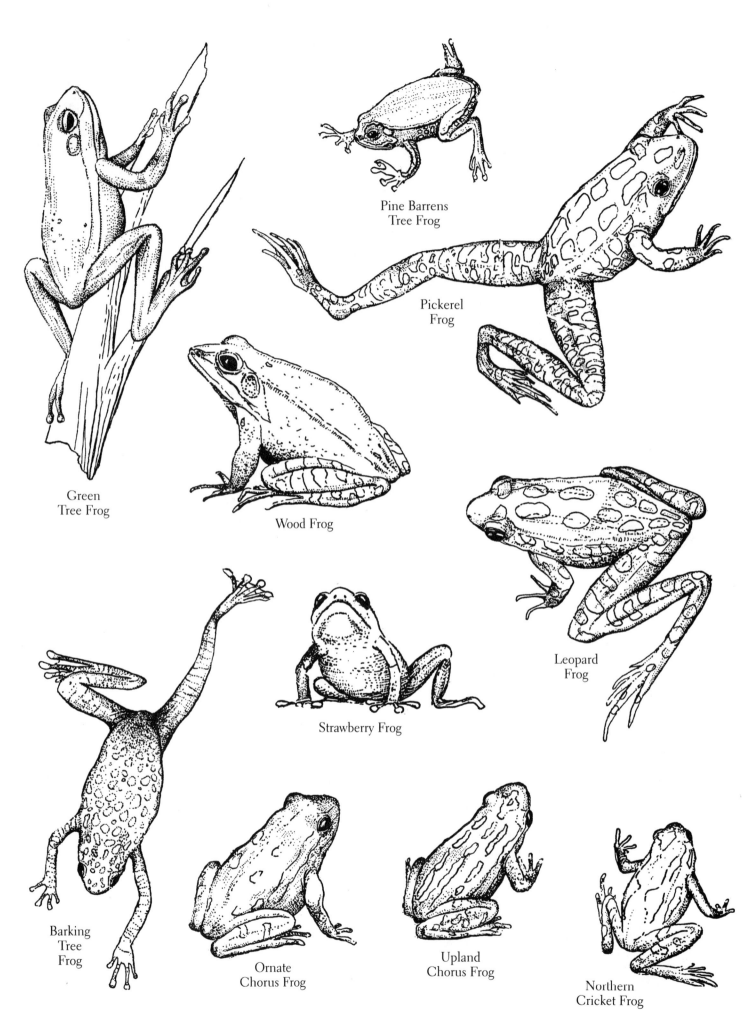

Pine Barrens
Tree Frog

Pickerel
Frog

Green
Tree Frog

Wood Frog

Leopard
Frog

Strawberry Frog

Barking
Tree
Frog

Ornate
Chorus Frog

Upland
Chorus Frog

Northern
Cricket Frog

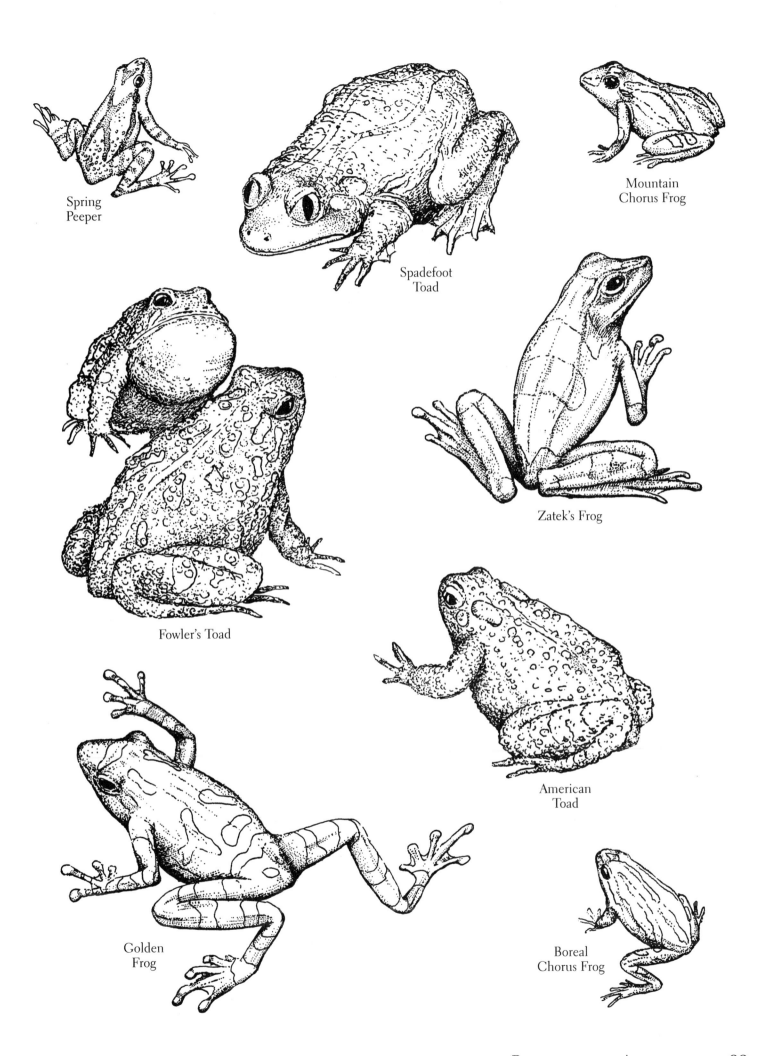

Spring
Peeper

Spadefoot
Toad

Mountain
Chorus Frog

Fowler's Toad

Zatek's Frog

American
Toad

Golden
Frog

Boreal
Chorus Frog

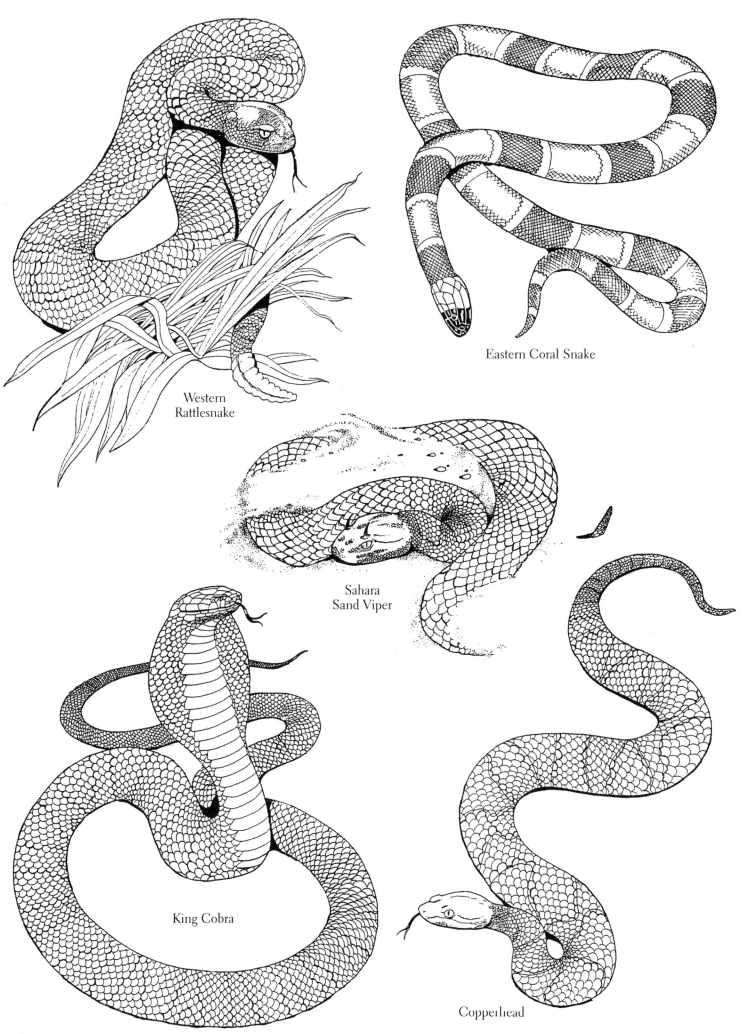

Western
Rattlesnake

Eastern Coral Snake

Sahara
Sand Viper

King Cobra

Copperhead

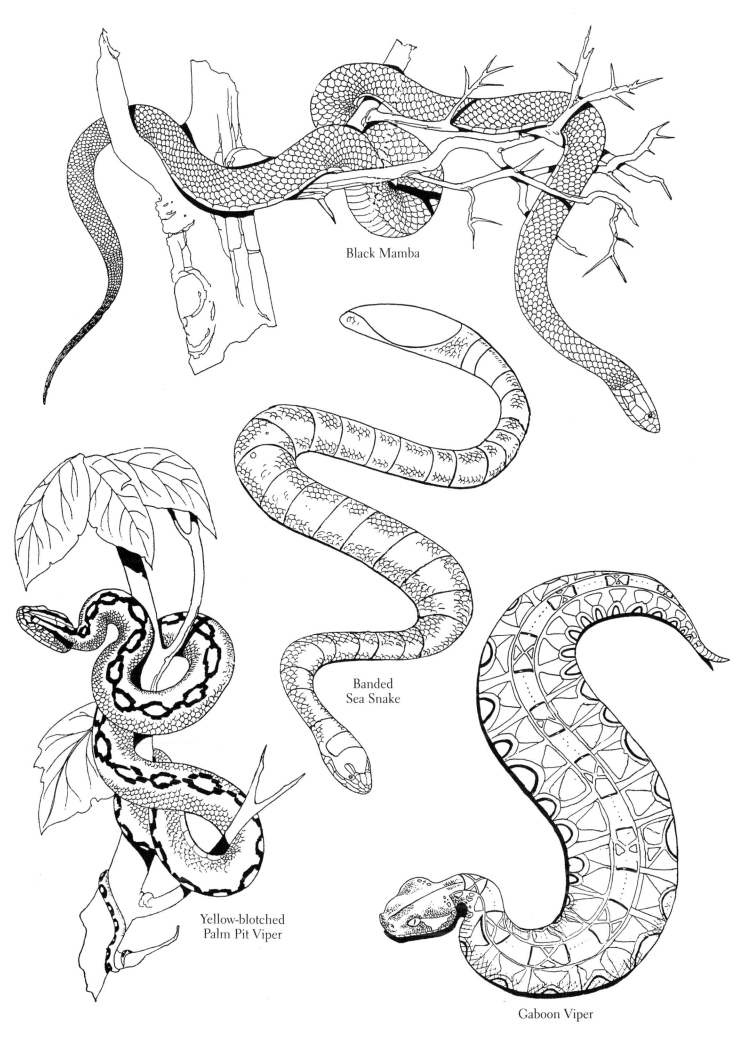

Black Mamba

Banded
Sea Snake

Yellow-blotched
Palm Pit Viper

Gaboon Viper

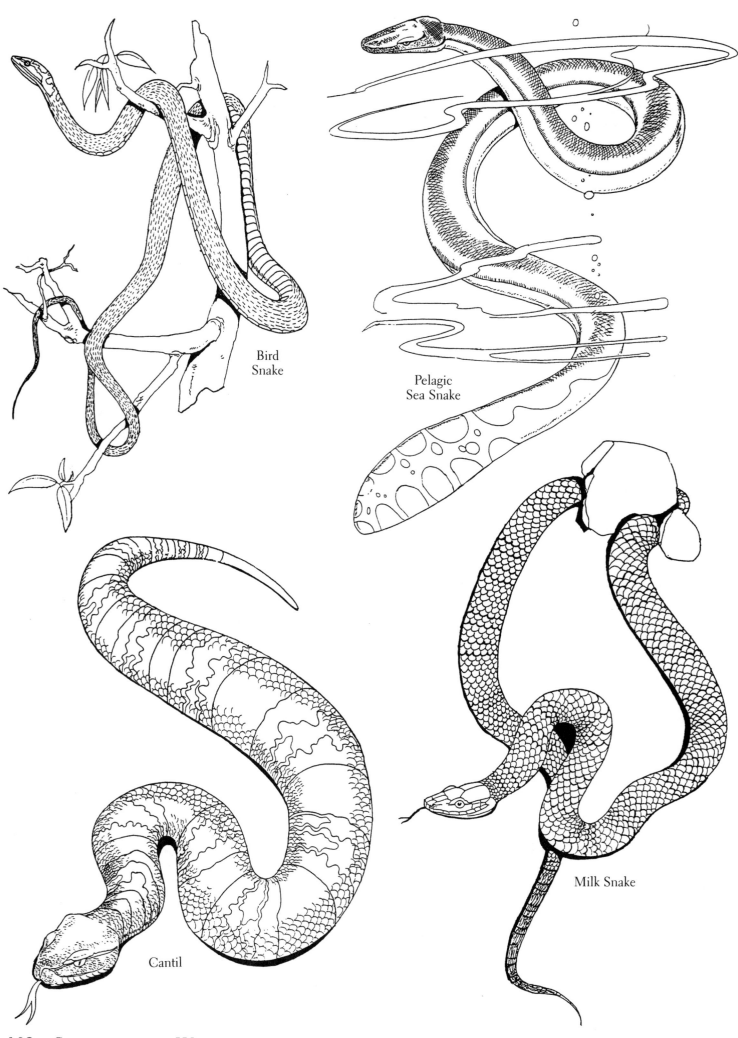

Bird
Snake

Pelagic
Sea Snake

Cantil

Milk Snake

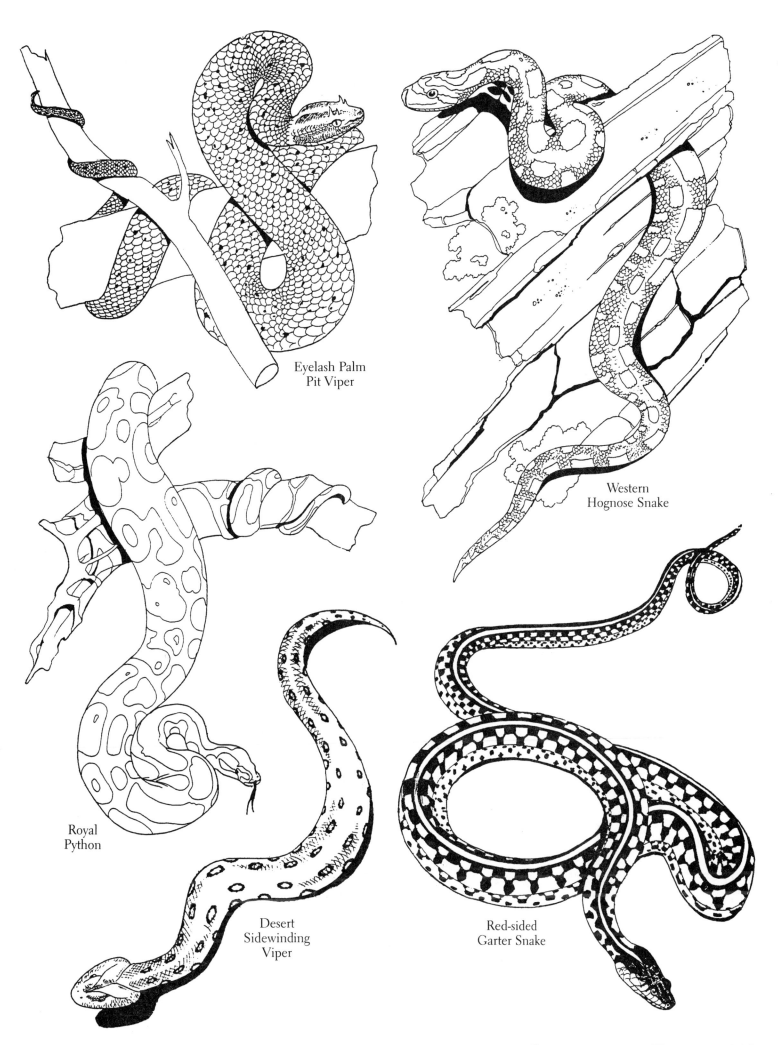

Eyelash Palm
Pit Viper

Western
Hognose Snake

Royal
Python

Desert
Sidewinding
Viper

Red-sided
Garter Snake

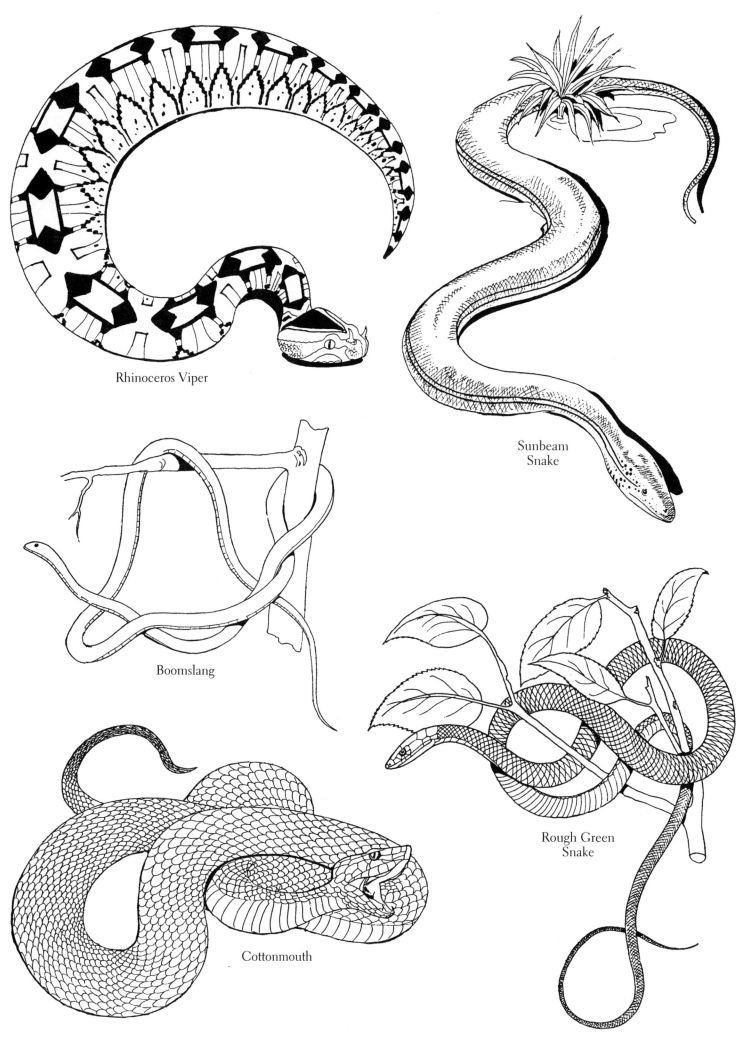

Rhinoceros Viper

Sunbeam
Snake

Boomslang

Rough Green
Snake

Cottonmouth

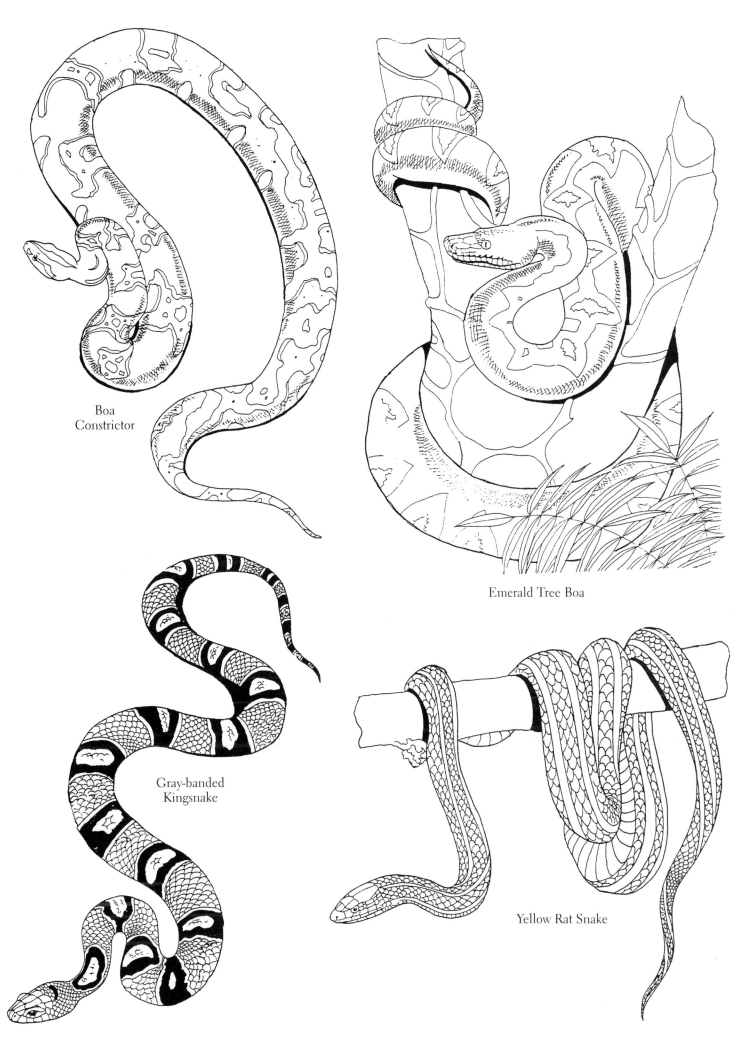

Boa
Constrictor

Emerald Tree Boa

Gray-banded
Kingsnake

Yellow Rat Snake

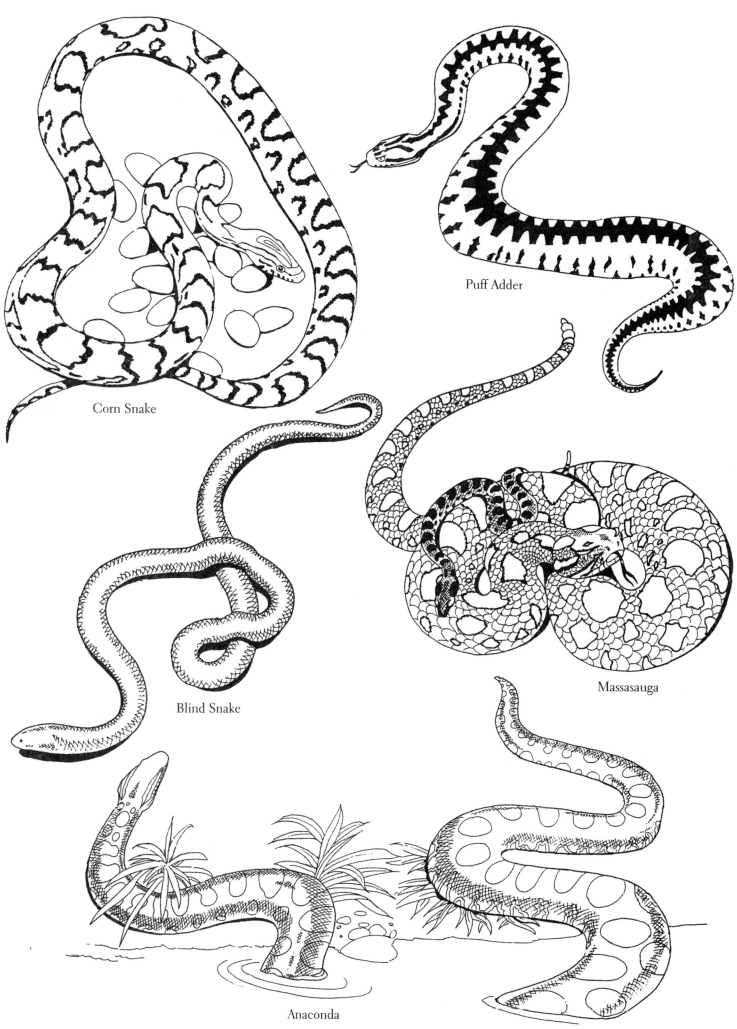

Corn Snake

Puff Adder

Blind Snake

Massasauga

Anaconda

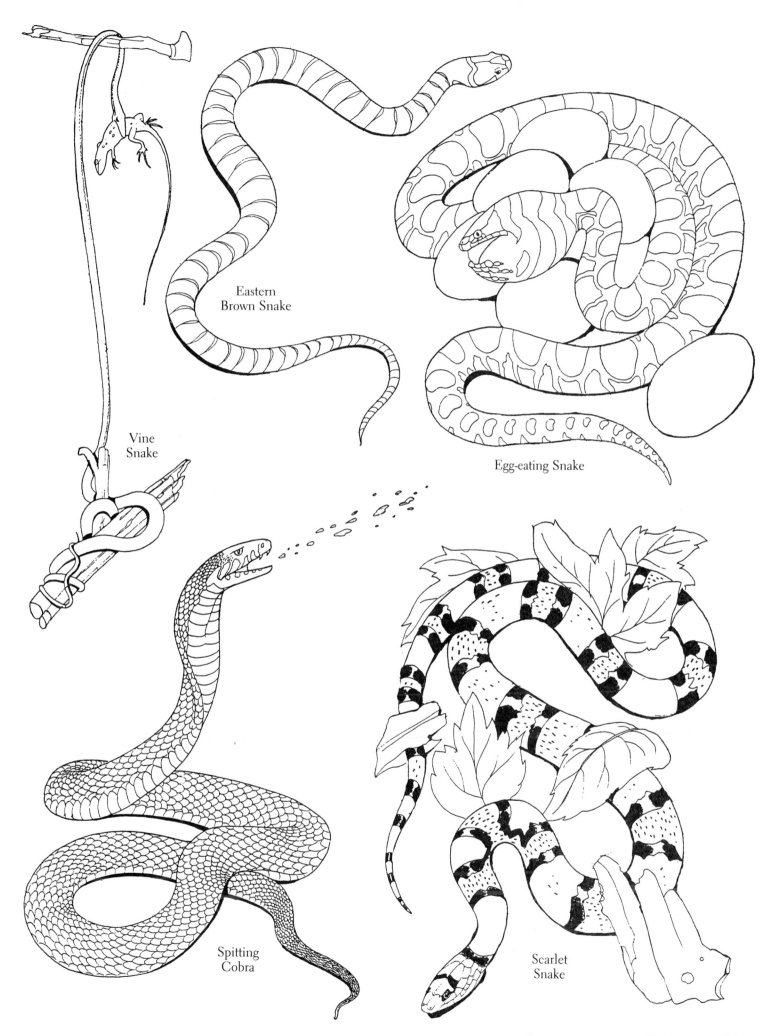

Eastern
Brown Snake

Vine
Snake

Egg-eating Snake

Spitting
Cobra

Scarlet
Snake

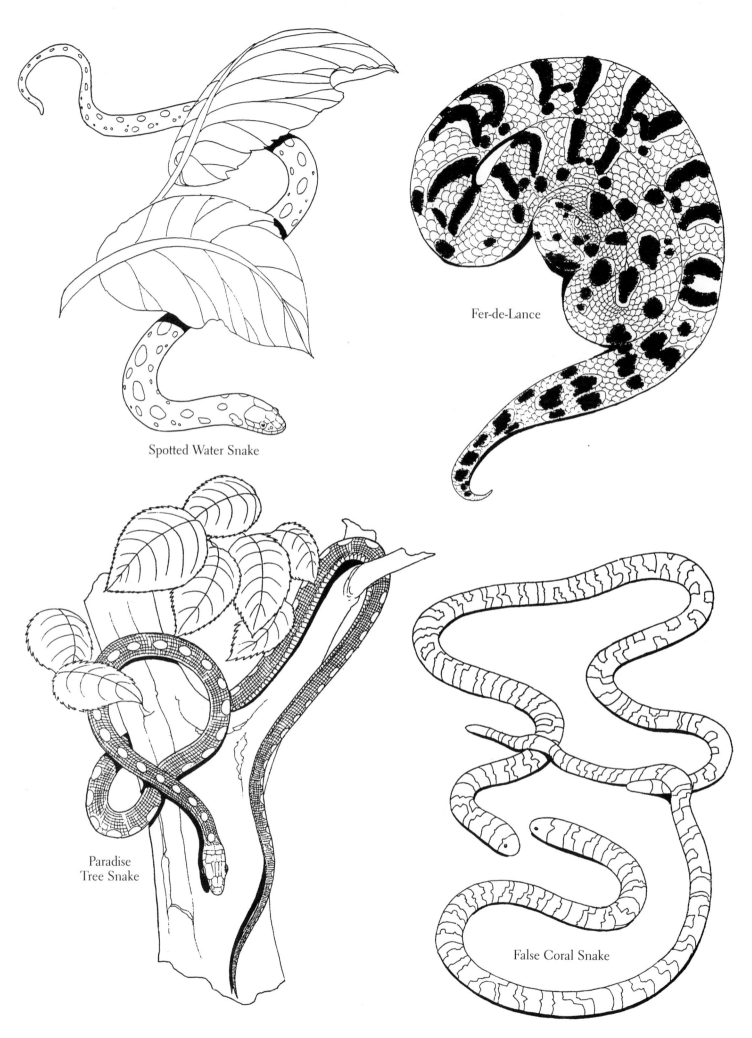

Spotted Water Snake

Fer-de-Lance

Paradise
Tree Snake

False Coral Snake

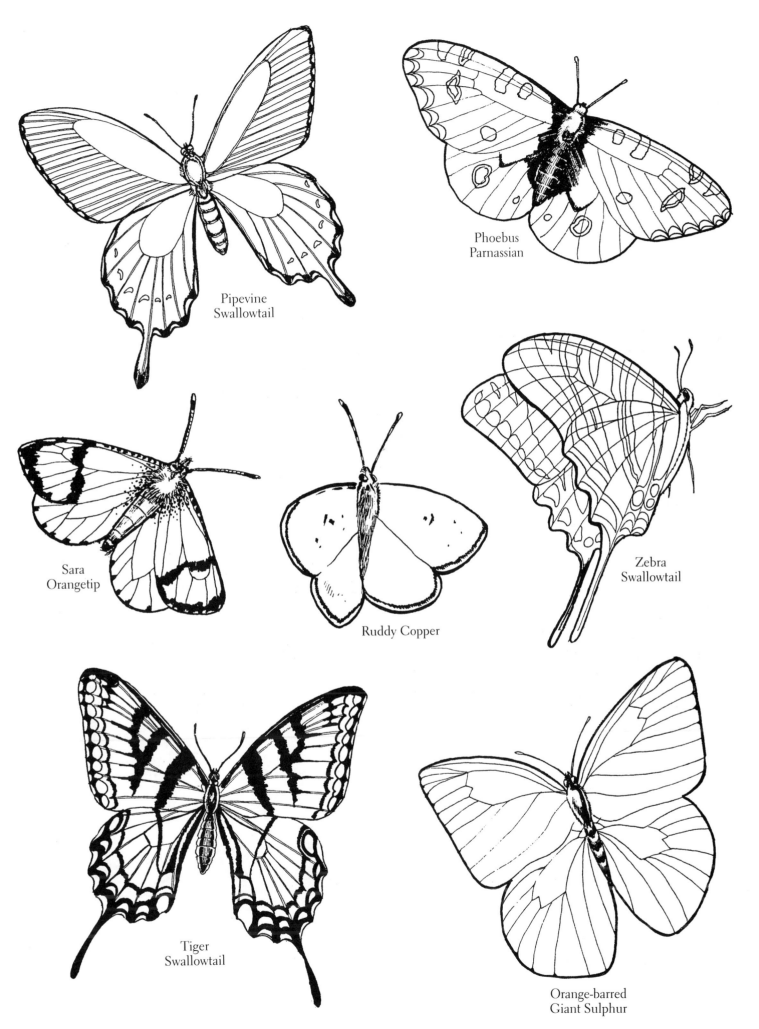

Pipevine
Swallowtail

Phoebus
Parnassian

Sara
Orangetip

Ruddy Copper

Zebra
Swallowtail

Tiger
Swallowtail

Orange-barred
Giant Sulphur

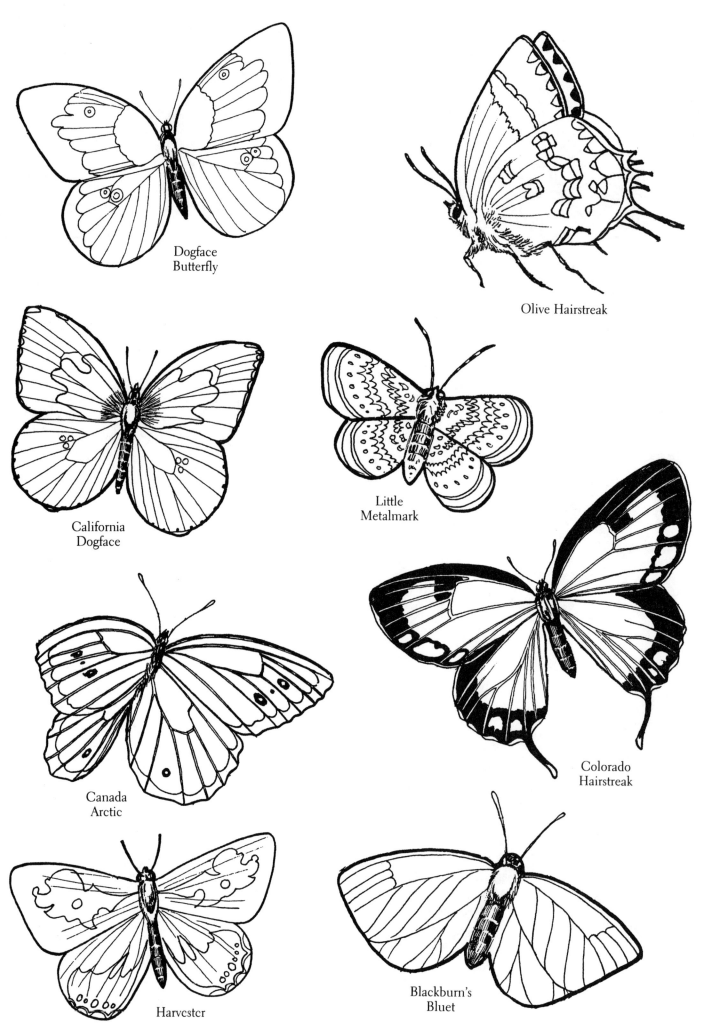

Dogface
Butterfly

Olive Hairstreak

California
Dogface

Little
Metalmark

Canada
Arctic

Colorado
Hairstreak

Harvester

Blackburn's
Bluet

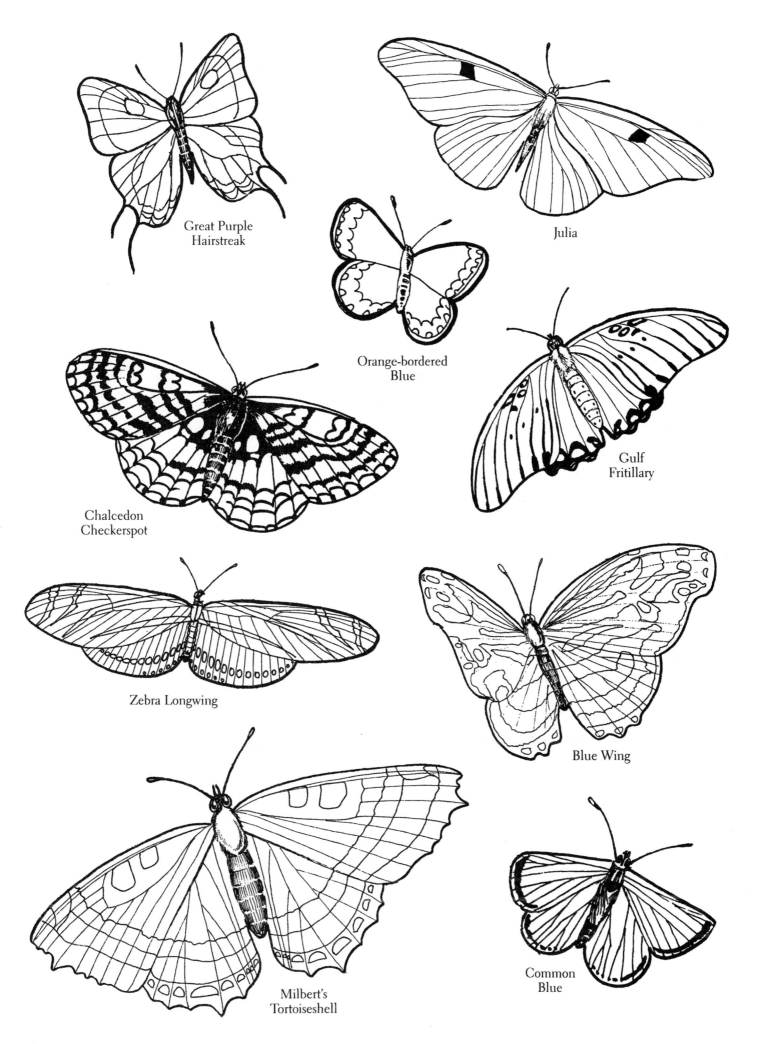

Great Purple
Hairstreak

Julia

Orange-bordered
Blue

Chalcedon
Checkerspot

Gulf
Fritillary

Zebra Longwing

Blue Wing

Milbert's
Tortoiseshell

Common
Blue

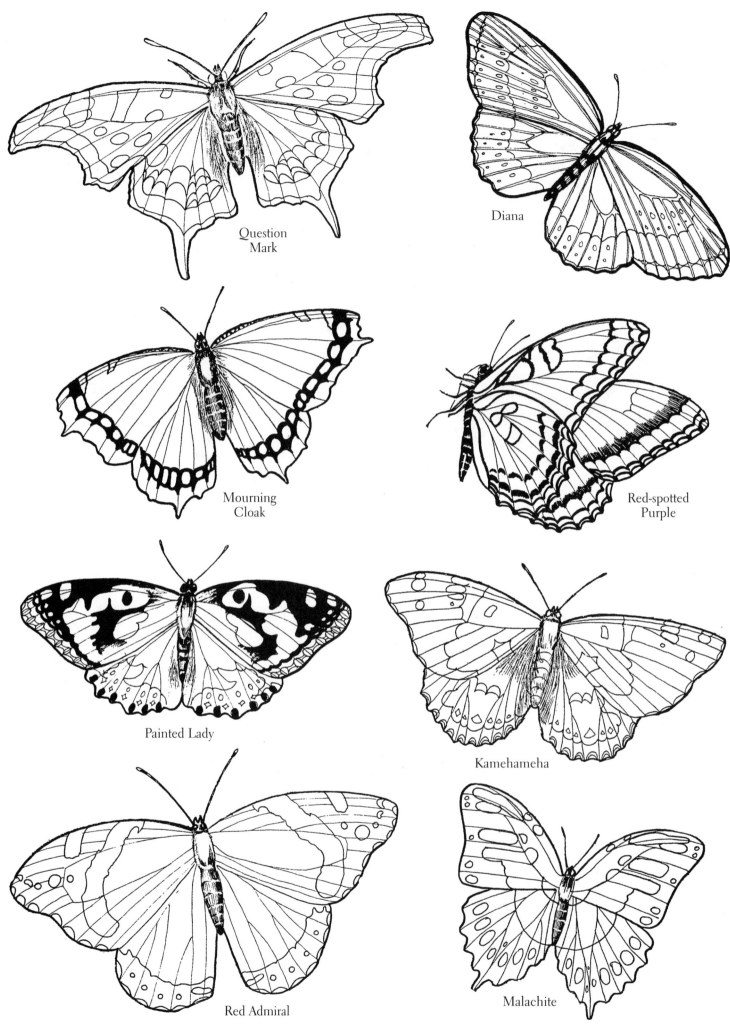

Question
Mark

Diana

Mourning
Cloak

Red-spotted
Purple

Painted Lady

Kamehameha

Red Admiral

Malachite

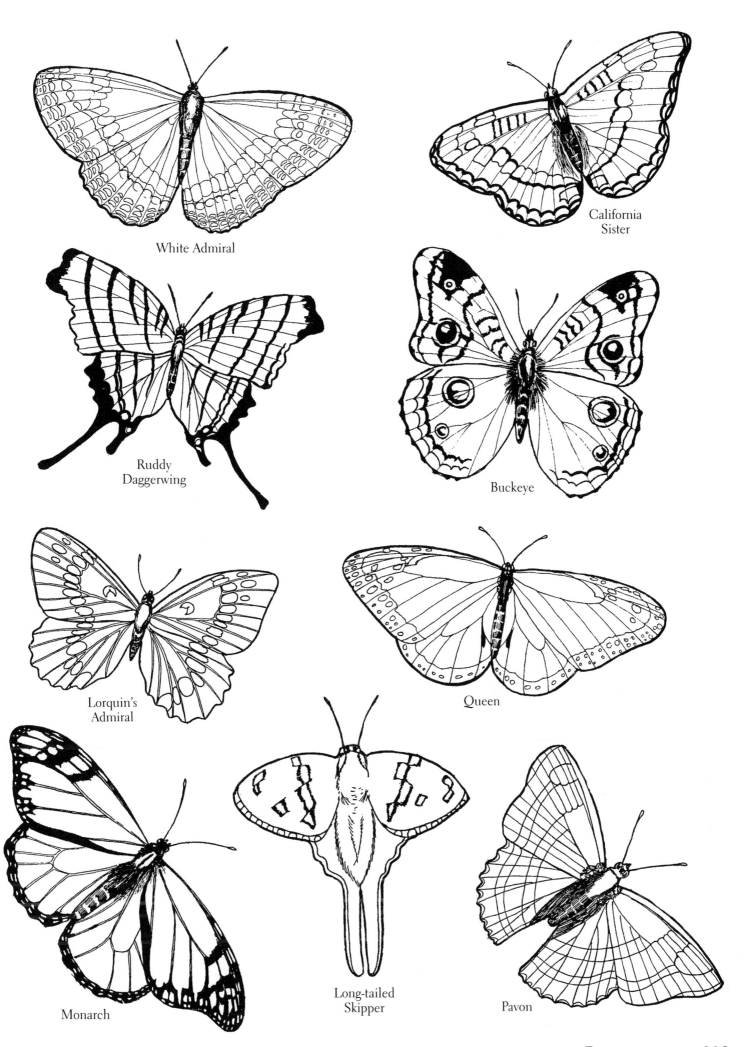

White Admiral

California
Sister

Ruddy
Daggerwing

Buckeye

Lorquin's
Admiral

Queen

Monarch

Long-tailed
Skipper

Pavon

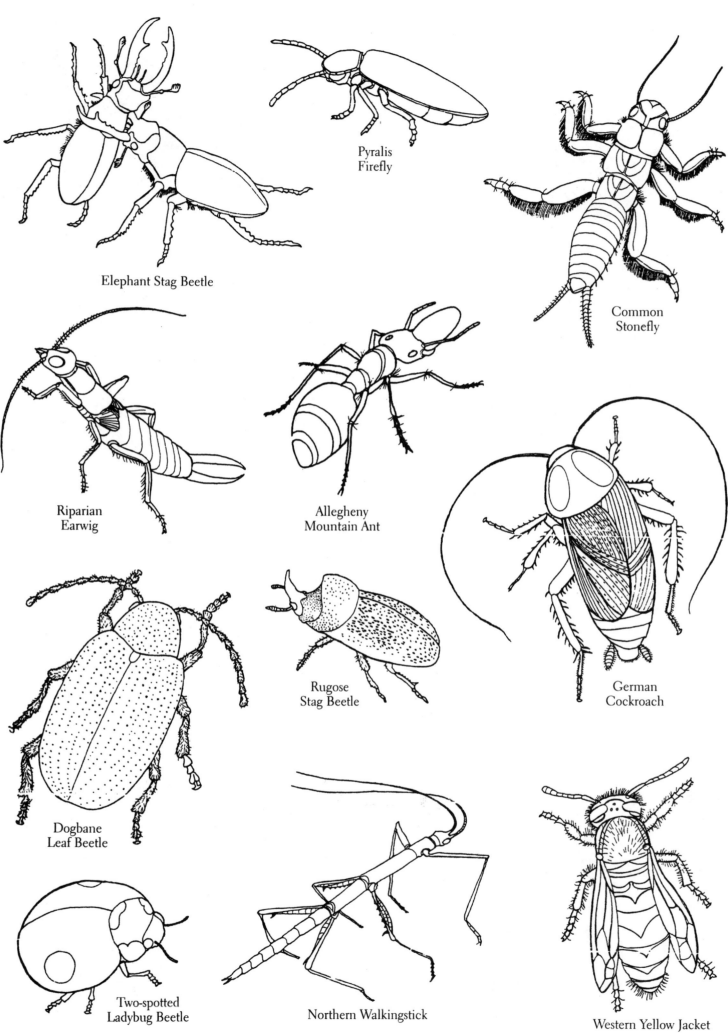

Pyralis
Firefly

Elephant Stag Beetle

Common
Stonefly

Riparian
Earwig

Allegheny
Mountain Ant

German
Cockroach

Dogbane
Leaf Beetle

Rugose
Stag Beetle

Two-spotted
Ladybug Beetle

Northern Walkingstick

Western Yellow Jacket

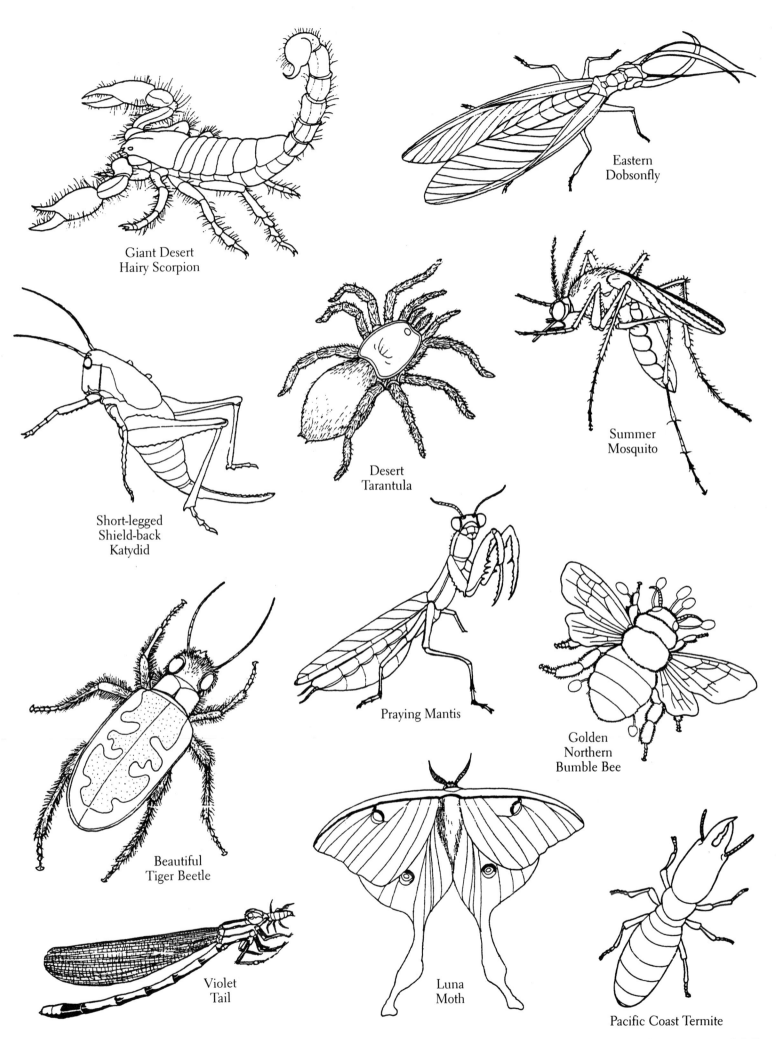

Giant Desert
Hairy Scorpion

Eastern
Dobsonfly

Short-legged
Shield-back
Katydid

Desert
Tarantula

Summer
Mosquito

Praying Mantis

Golden
Northern
Bumble Bee

Beautiful
Tiger Beetle

Violet
Tail

Luna
Moth

Pacific Coast Termite

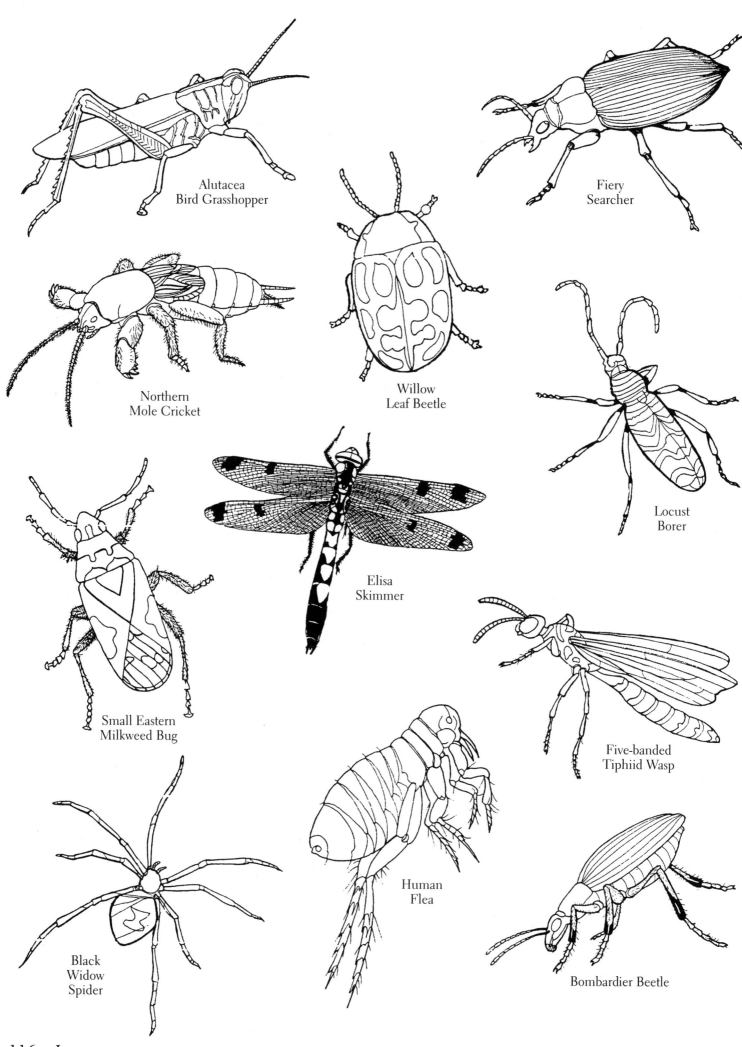

Alutacea
Bird Grasshopper

Fiery
Searcher

Northern
Mole Cricket

Willow
Leaf Beetle

Locust
Borer

Small Eastern
Milkweed Bug

Elisa
Skimmer

Five-banded
Tiphiid Wasp

Black
Widow
Spider

Human
Flea

Bombardier Beetle

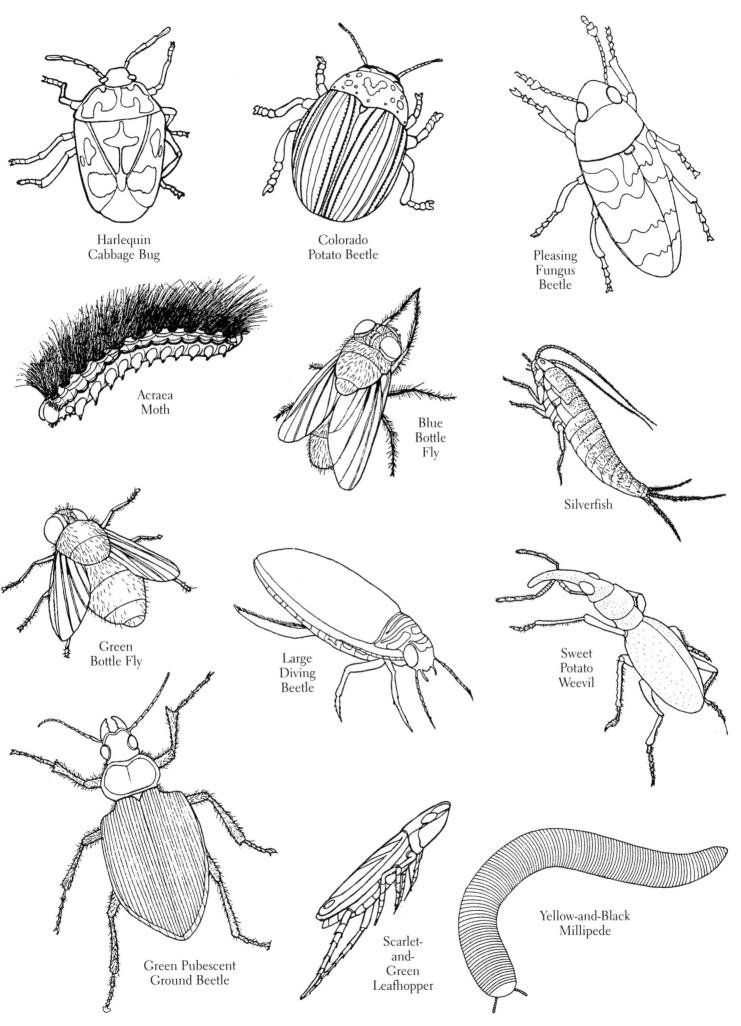

Harlequin
Cabbage Bug

Colorado
Potato Beetle

Pleasing
Fungus
Beetle

Acraea
Moth

Blue
Bottle
Fly

Silverfish

Green
Bottle Fly

Large
Diving
Beetle

Sweet
Potato
Weevil

Green Pubescent
Ground Beetle

Scarlet-
and-
Green
Leafhopper

Yellow-and-Black
Millipede

Index

Sources of the Illustrations

The Dinosaur Coloring Book, Anthony Rao
(Copyright © 1980 Anthony Rao)

Prehistoric Mammals Coloring Book, Jan Sovak
(Copyright © 1991 Dover Publications, Inc.)

Small Animals of North America Coloring Book, Elizabeth A. McClelland
(Copyright © 1981 Dover Publications, Inc.)

Wild Animals Coloring Book, John Green
(Copyright © 1987 John Green)

North American Desert Life Coloring Book, Ruth Soffer
(Copyright © 1994 Dover Publications, Inc.)

African Plains Coloring Book, Dianne Gaspas-Ettl
(Copyright © 1996 Dover Publications, Inc.)

Wild Cats of the World Coloring Book, John Green
(Copyright © 1988 John Green)

Swampland Plants and Animals Coloring Book, Ruth Soffer
(Copyright © 1997 Dover Publications, Inc.)

Monkeys and Apes Coloring Book, John Green
(Copyright © 1988 John Green)

Arctic and Antarctic Life Coloring Book, Ruth Soffer
(Copyright © 1998 Dover Publications, Inc.)

Zoo Animals Coloring Book, Jan Sovak
(Copyright © 1993 Dover Publications, Inc.)

Horses of the World Coloring Book, John Green
(Copyright © 1985 John Green)

Reptiles and Amphibians Coloring Book, Thomas C. Quirk, Jr.
(Copyright © 1981 Dover Publications, Inc.)

Snakes of the World Coloring Book, Jan Sovak
(Copyright © 1995 Jan Sovak)

Butterflies Coloring Book, Jan Sovak
(Copyright © 1992 Dover Publications, Inc.)

Insects Coloring Book, Jan Sovak
(Copyright © 1994 Jan Sovak)